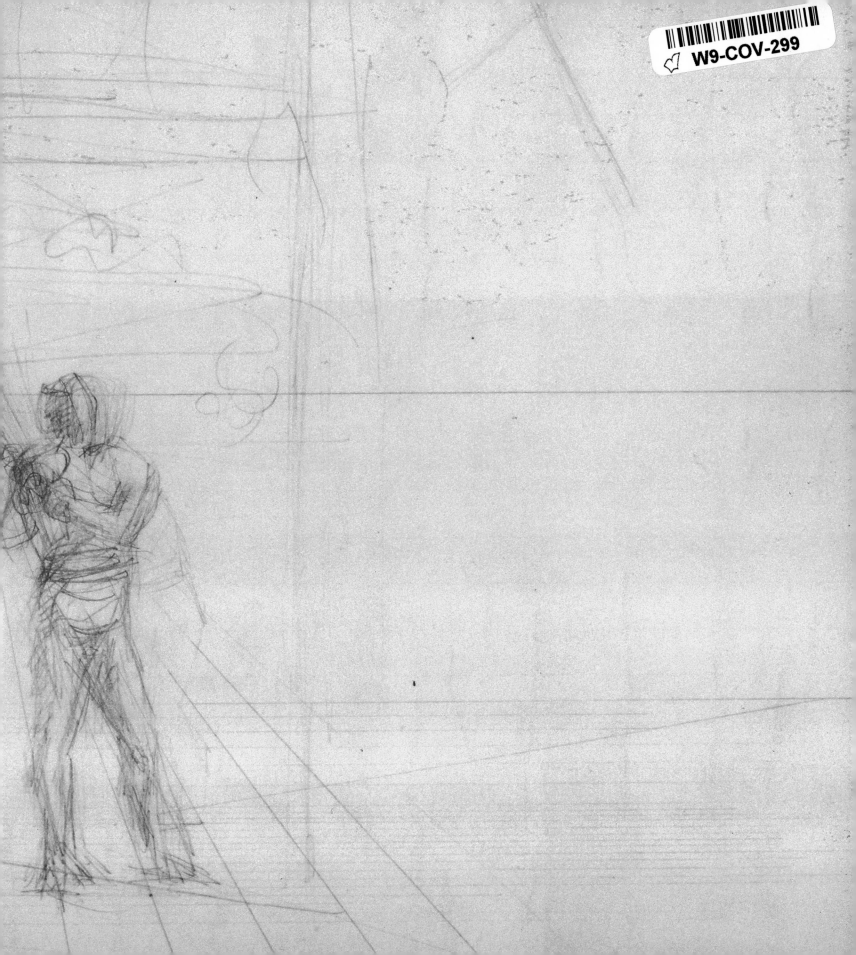

THOMAS EAKINS
THE ABSOLUTE MALE

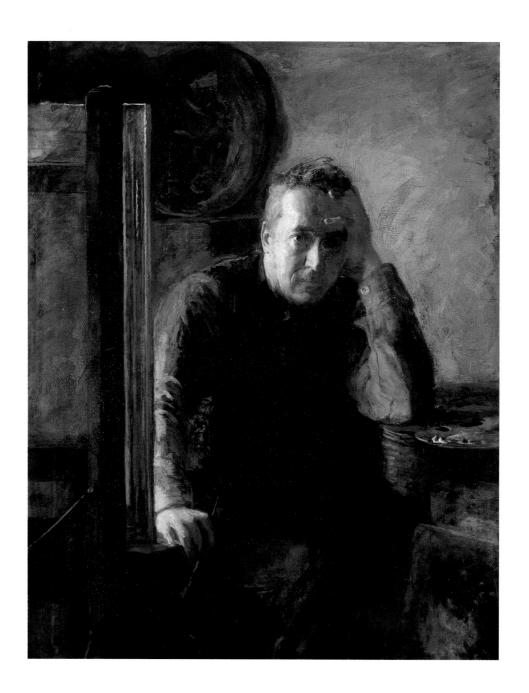

THOMAS EAKINS
THE ABSOLUTE MALE

JOHN ESTEN

UNIVERSE

Then every man of every clime,
That prays in his distress,
Prays to the human form divine
Love Mercy Pity Peace.

—*William Blake*

Figure Study: Two Knees, ca. 1863–66.

Eakins was admitted into the life drawing classes at the
Pennsylvania Academy of the Fine Arts in 1863.

OPPOSITE TITLE PAGE:
SUSAN MACDOWELL EAKINS, *Portrait of Thomas Eakins,* ca. 1920–25.

A student of Eakins, Susan Macdowell was an accomplished painter who married the artist in 1884. Susan Eakins
painted the posthumous portrait of her husband from a photograph she took of him circa 1899.

ENDPAPERS:
Perspective Study of Baseball Players, 1875.

First published in the United States of America in 2002 by
UNIVERSE PUBLISHING
A Division of Rizzoli International Publications, Inc.
300 Park Avenue South
New York, NY 10010

© 2002 Universe Publishing/John Esten

2002 2003 2004 2005 2006 2007 / 10 9 8 7 6 5 4 3 2 1
Library of Congress Cataloging-in-Publication Data

Esten, John, 1935-
 Thomas Eakins : the absolute male / John Esten.
 p. cm.
Includes bibliographical references and index.
 ISBN 0-471-44365-4
 1. Eakins, Thomas, 1844-1916--Catalogs. 2. Male nude in
art--Catalogs. 3. Photography of the nude--Catalogs. I. Eakins,
Thomas, 1844-1916. II. Title.
 N6537.E3 A4 2002
 709'.2--dc21

 2002001243

CREDITS:
Book design: John Esten
Digital composition: Mary McBride
Printed in Singapore
ISBN: 0-7893-0678-6

CONTENTS

FOREWORD/ACKNOWLEDGMENTS *9*

THE ABSOLUTE MALE *13*

CHRONOLOGY *74*

NOTES *75*

SELECT BIBLIOGRAPHY *76*

LIST OF ILLUSTRATIONS *77*

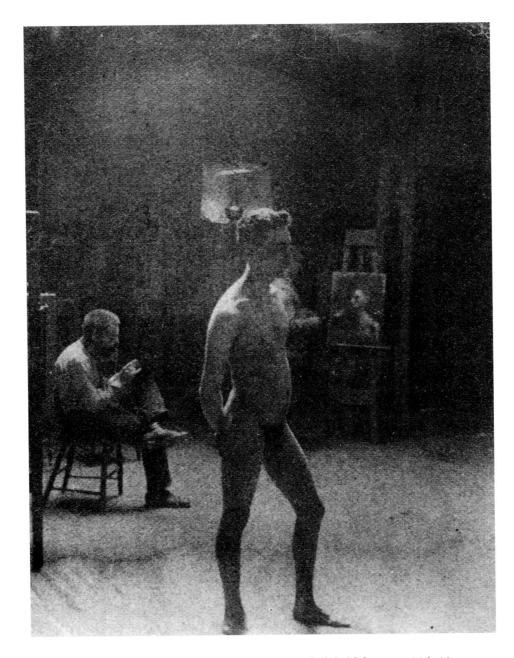

John Wright Posing at the Art Students League of Philadelphia, ca. 1886–92.

The seated figure sketching in the studio has been tentatively identified as Thomas Eakins.

FOREWORD/ACKNOWLEDGMENTS

MORE THAN A CENTURY has passed since Thomas Eakins caused the legendary scandal by revealing the absolute male nude to one of his classes at the Pennsylvania Academy of the Fine Arts in February 1886.

Times have changed. The undressed male model has become an undisputed visual icon. The male figure has been given equal and sometimes greater status than the female's as a sexual object. "Buffed-up" male bodies have become staple fixtures on billboards and in magazines, catalogues, and TV commercials, promoting such diverse products as fragrance, underwear, and luxury cars, and are a ubiquitous aspect of popular culture today.

It is difficult now to imagine that during Eakins's lifetime, and until very recently, these images of flagrantly erotic male models would have been regarded as unadulterated pornography.

In preparing this book, many people have helped in many ways—some with scholarship, some with interest and enthusiasm, and others with kindness, patience, and their valuable time.

I am deeply appreciative for the professional assistance of individuals associated with museums and other cultural institutions: Julie Dunn, Addison Gallery of American Art, Phillips Academy; Courtney DeAngelis, Amon Carter Museum; Mary Lineberger, Cleveland Museum of Art; Jennifer Seeds, Columbus Museum of Art; Sylvia Inwood, Detroit Institute of Arts; John Alviti, Franklin Institute Science Museum; Jacklyn Burns, J. Paul Getty Museum; Phyllis Rozenweig and Amy Densford, Hirshhorn Museum and Sculpture Garden; Mary Dougherty and Jerry Wagner, Metropolitan Museum of Art; Barbara Katus, Pennsylvania Academy of the Fine Arts; Mark Piel, New York Society Library; Stacey Bomento, Philadelphia Museum of Art; Kris Walton, Sterling and Francine Clark Art Institute; and Suzanne Warner, Yale University Art Gallery.

I would also like to thank Elizabeth Parella for initially editing my text, and Jessica Fuller, my editor, for its final edit, along with her support throughout the many aspects of this project. I am most grateful to Charles Miers, publisher of Universe/Rizzoli International, whose insight helped make an idea a reality. Bonnie Eldon, managing editor, and Felix Gregorio of Universe Publishing were equally supportive.

I am indebted to Mary McBride for her expertise and diligence in converting my words and layout design into a computer format to make the book. □

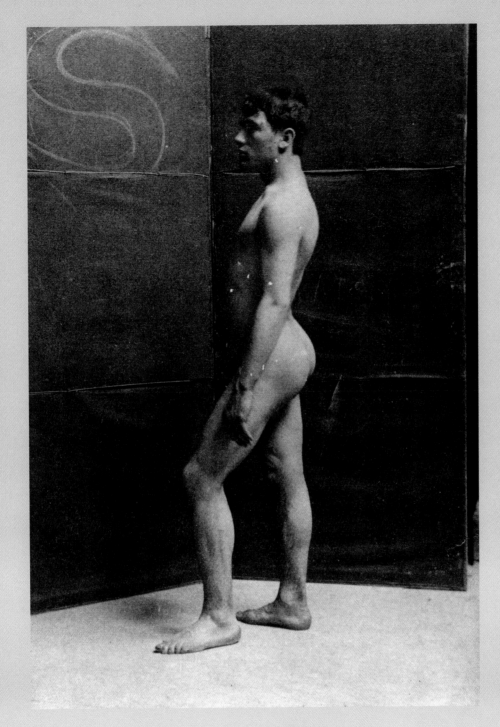

Tom Eagan, in Front of a Folding Screen, ca. 1889.

One of a series of four photographs Eakins made of Tom Eagan,
believed to have been taken in the studio of the
Philadelphia Art Students League.

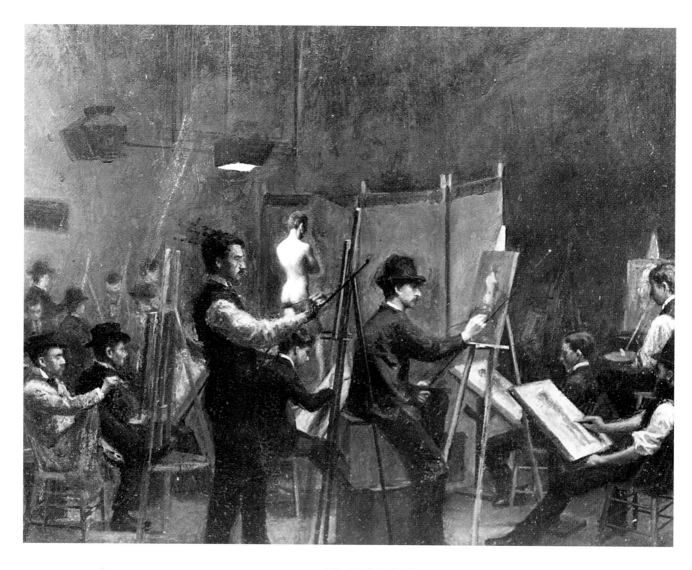

WALTER M. DUNK: *The Male Life Class,* ca. 1879.

A typical life class at the Pennsylvania Academy of the Fine Arts
painted during the time Eakins was teaching there.
The life classes at the school were segregated by gender.

THE ABSOLUTE MALE

*I see no impropriety in looking
at the most beautiful of Nature's works,
the naked figure.*[1]

— THOMAS EAKINS

T HOMAS COWPERTHWAIT EAKINS believed that the nude human body was the most beautiful object on this earth— not an object of desire, but a miracle of muscle, bone, and blood.

Eakins was born in Philadelphia in 1844 where he lived most of his seventy-one years. As a child he received calligraphy and drawing lessons from his father, Benjamin Eakins, a writing master, and a professional calligrapher who taught penmanship at the Society of Friends' Central School for fifty-one years. At age thirteen, Eakins entered Central High School, a singular institution in the city modeled on the Latin School of Boston, which endeavored to educate young men regardless of their social or financial background provided they could pass the stringent entrance examination. Eakins soon demonstrated an exceptional interest and aptitude for science and art. After graduating with honors in 1861, he enrolled at the Pennsylvania Academy of the Fine Arts, the oldest chartered art school in America.

During his first four months at the Pennsylvania Academy, Eakins pursued the monotonous requirement of drawing plaster casts of classical sculpture and attended lectures on anatomy before he was admitted to the life drawing classes to begin drawing live nude models.

To develop further his understanding of the human figure while working at the Academy, Eakins studied anatomy by dissection at Jefferson Medical College under the distinguished surgeon, Joseph Pancoast, "to increase his knowledge of how beautiful objects are put together" so that he would "be better able to imitate them."[2]

In September of his twenty-second year, with his father's blessing and financial support, the accomplished draftsman and anatomist traveled to Paris where he became the second American accepted to study in the atelier of Jean-Léon Gérôme at the Ecole des Beaux-Arts. Gérôme, a popular painter of the Paris salon, emphasized the

traditional Beaux-Arts precept of portraying the classical or idealized figure.

Eakins soon determined that idealizing the human figure was a delusion, when in reality the unromanticized body was so beautiful. The young art student felt that "to idealize—one must understand what he is idealizing, otherwise his idealization—I don't like the word—becomes distortion, and distortion is ugliness."[3] He real-ized that he learned more about the figure by observing and sketching his classmates when they undressed and wrestled together in Gérôme's studio than he did from studying antique casts or drawing posed models.

When he returned from Europe in 1870, Eakins resumed the athletic activities he had missed there—baseball, boxing, rowing on the Schuylkill River, sailing, and swimming were some

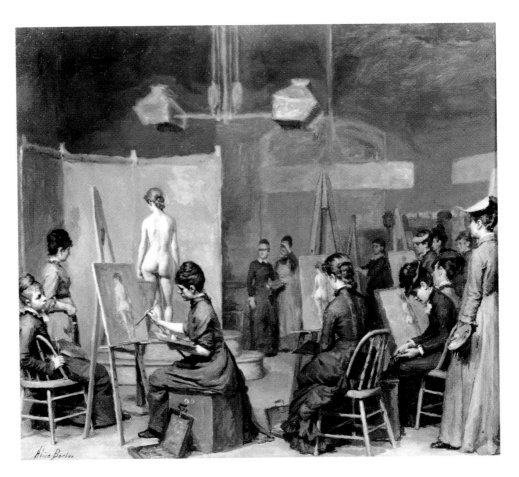

ALICE BARBER STEPHENS, *The Women's Life Class,* ca. 1879.

The art student and future wife of Eakins, Susan Macdowell, is depicted in the painting working on a canvas (left) in the women's life class at the Pennsylvania Academy of the Fine Arts.

of the virile pursuits he participated in or chose as subjects to paint. Eakins became the first artist to depict the masculine sphere (today called macho) of sports in which he portrayed unidealized young American men in ordinary attitudes and activities. Along with his contemporary Winslow Homer, Eakins was a complete realist who portrayed the middle-class world of his period and place.

The artist not only painted the nude to reveal his knowledge of the human figure, he painted portraits of his family and friends in their familiar environments. His first major portrait, *The Gross Clinic,* is a painting of another surgeon he had studied with, Dr. Samuel D. Gross, who is demonstrating a medical procedure to his assembled students at Jefferson Medical College, and it remains among Eakins's seminal works.

When the Pennsylvania Academy moved into

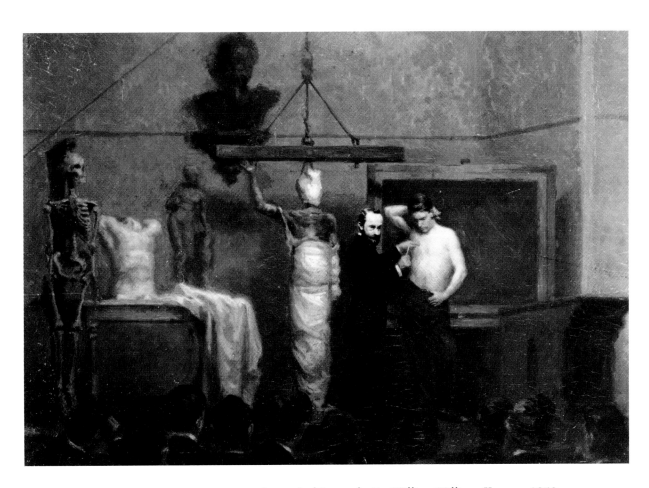

CHARLES H. STEPHENS, *Anatomical Lecture by Dr. William Williams Keen,* ca. 1879.

A surgeon and medical textbook author, Dr. Keen is portrayed lecturing to an anatomy class at
the Pennsylvania Academy. Eakins assisted Dr. Keen with his classes when he first began teaching at the school.

its new neo-Gothic building at Broad and Cherry Streets in 1876, Eakins began teaching life and anatomy classes part-time, and in 1882, after his appointment as director of the school, he emphasized a "course of study [that] is believed to be more thorough than that of any other existing school. Its basis is the nude human figure."[4] To further augment the study of the figure (although not taught officially as a course), Eakins introduced the newest medium of picture making, photography, which bridged science and art.

While studying at the Ecole Des Beaux-Arts, Eakins became aware that photography could be used as an accurate means for gathering visual information. As early as 1880, he owned a four-inch x five-inch optical box camera and began experimenting with photography as a reference for his work as well as teaching aids. One of the teaching aids, called the "naked series," (pages *26–27*) is composed of small, static, standing figures of a model or models in sequential poses glued to cardboard.

To understand the anatomy of the moving figure, in 1884 Eakins assisted the English photographer Eadweard Muybridge in his animal locomotion experiments at the University of Pennsylvania that consisted of humans and horses walking, running, and jumping, and was a precursor of cinematography. He also experimented on his own using a photographic technique invented by the French scientist Etienne-Jules Marey. An Eakins photograph of one of his students jumping (page *34*) was described by William Dennis Marks in 1888:

The reproduction of a boy jumping horizontally…which professor Eakins has photographed on a single plate by means of his adoption of the Marey wheel, is of exceedingly great interest because, in this picture, each impression occurred at exact intervals. The velocity of motion can be determined, by measurement of the spaces separating the successive figures, with very great precision, as also the relative motions of the various members of the body.[5]

More than any other nineteenth-century American artist, photography became a seminal part of Eakins's work. Produced during the 1880s and 1890s, the images were not intended for public view or sale, unlike his paintings. The photographs have since placed Eakins among the paramount photographers of that era.

Eakins frequently encouraged his students to pose nude for each other in class and for himself in his Chestnut Street studio or in various outdoor locations where he photographed them. His male students seemed to have no inhibitions about posing nude; indeed, in some of the group compositions (pages *62–71*) they appear to be reveling in the exercise. The only female student who dared to pose undressed was Susan Macdowell, whom Eakins married in 1884.

The artist further magnified these incendiary practices when, in his eagerness to teach the complete male anatomy to a class of female students in 1886, Eakins removed the model's loincloth, causing the women to view what the *Philadelphia Evening Bulletin* described as "the

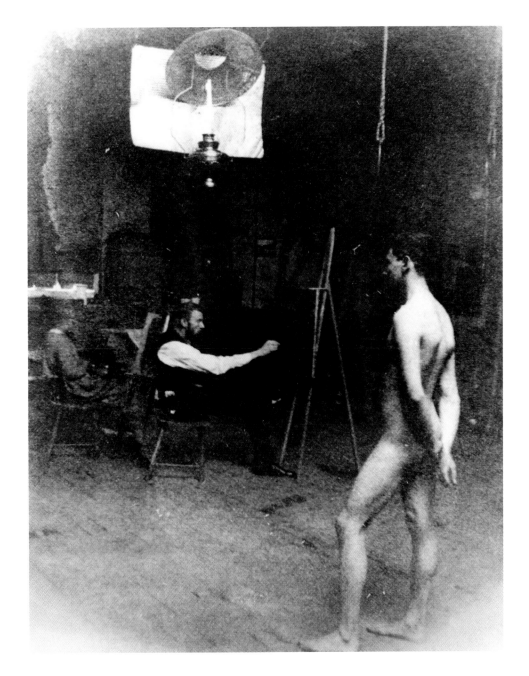

Photograph at the Art Students League of Philadelphia, 1886–92.

Model James Wright posing for a class of students of both sexes at the Art Students League.
This was a complete break with the policy of segregated life classes
at the Pennsylvania Academy of the Fine Arts.

absolute [male] nude." The artist was asked to resign, in disgrace, from the Pennsylvania Academy of Fine Arts and was ignored by the polite Quaker city establishment. As Anne McCauley has so succinctly pointed out, "the only surprising thing about [the] dismissal of Eakins was that it did not come earlier."[6]

The scandal and rejection of Eakins prompted thirty-eight of his students to withdraw from the school and establish an alternative to the conservative policies of the Pennsylvania Academy—the Art Students League of Philadelphia, a cooperative organization with Eakins as instructor. The artist taught without any remuneration. Charles Bregler, who studied under Eakins at the Academy and the Art Students League, observed later that Eakins's students possessed "love, loyalty, devotion and complete faith in the ultimate recognition of [Eakins's] masterly paintings."[7]

While still a student in Paris, Eakins scorned the prudery concerning the depiction and display of the nude figure in art. In a letter to his father he observed that

[t]he French court is become very decent since Eugenie had fig leaves put on all the statues in the Garden of the Tuileries & when a man paints a naked woman he gives her less than poor Nature herself did. I can conceive few circumstances wherein I would have to paint a woman naked but if I did I would not mutilate her for double the money. She is the most beautiful thing there is [in] the world except a naked man but I never saw a study of one exhibited.[8]

In spite of unparalleled prejudice and self-conscious convention, Eakins championed the nude human figure in paint and photography. His achievements and contributions to American art are without precedent. As his friend Walt Whitman so aptly put it, "I never knew of but one artist, and that's Tom Eakins, who could resist the temptation to see what they think ought to be rather than what is."[9] □

Plan and Perspective Study of the Artist's Signature:
for Portrait of Dr. John H. Brinton, 1876.

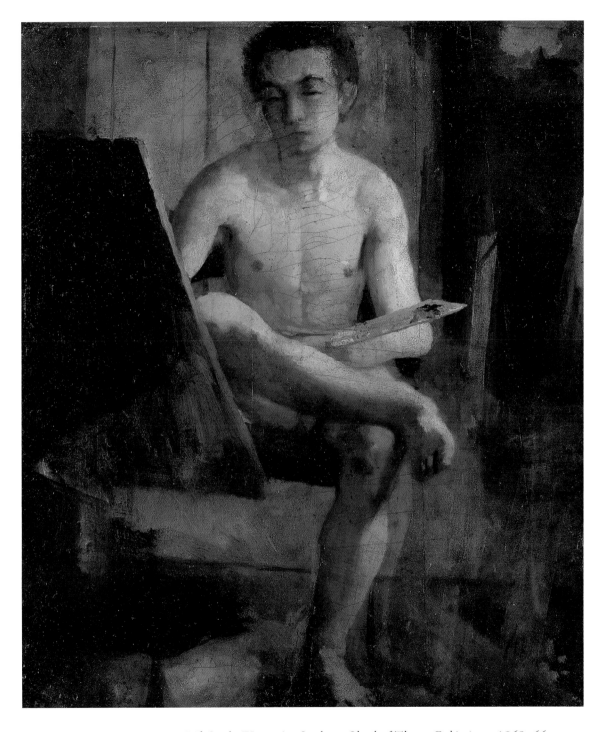

CHARLES FUSSELL, *Life Study (Young Art Student—Sketch of Thomas Eakins)*, ca. 1865–66.

While studying at the Pennsylvania Academy of the Fine Arts, Charles Fussell portrayed his classmate, Thomas Eakins, painting in the nude. By posing nude for each other the men were able to extend their study of the human figure.

CHARLES TRUSCOTT
*Cast Drawing Room at the Pennsylvania Academy
of the Fine Arts,* ca. 1890s.

The light-washed studio in the Pennsylvania Academy
contained the largest collection of casts
of antique sculpture in America.

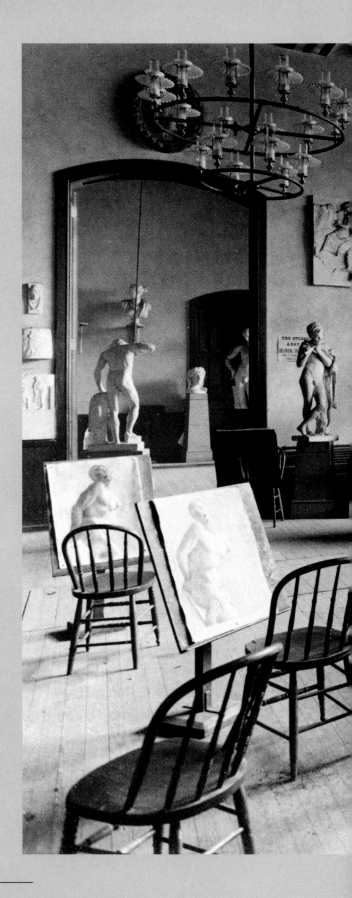

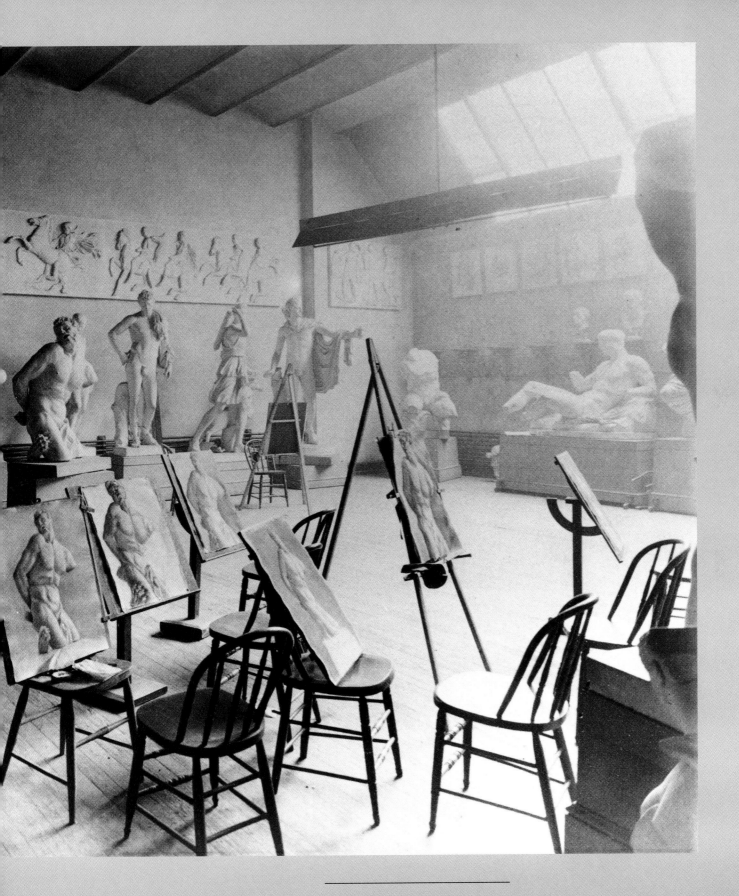

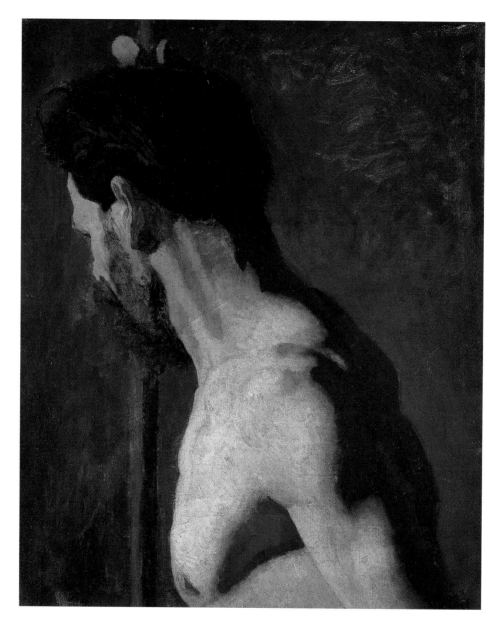

Study of a Nude Man (The Strong Man), ca. 1869.

These torsos of a male nude (above and opposite) are thought
to have been painted when Eakins was a student in Paris.

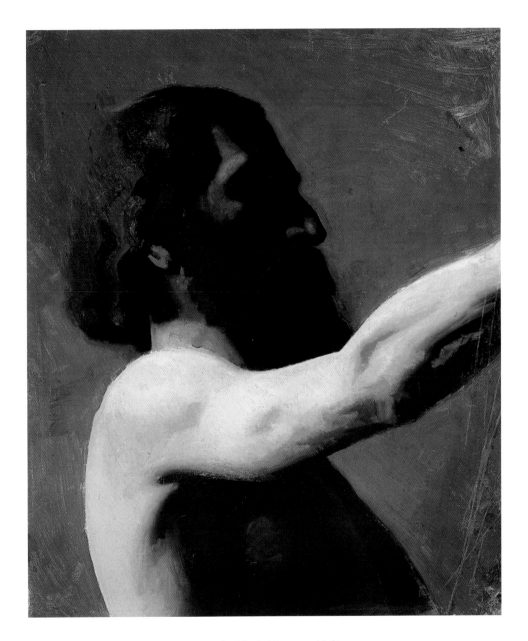

Bust of a Nude Man, ca. 1869.

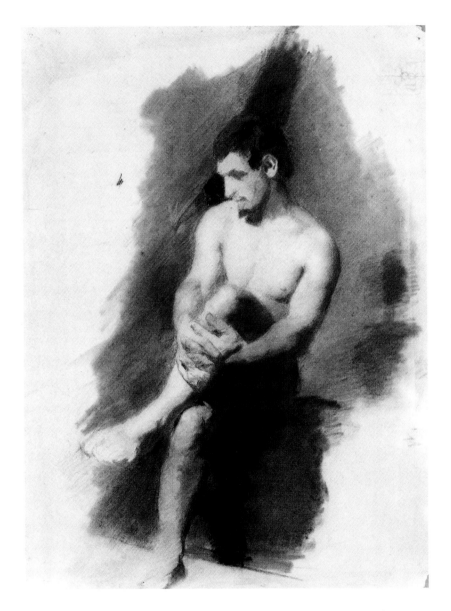

Man Seated, Hands Clasped Around Crossed Knees ca. 1874–76.

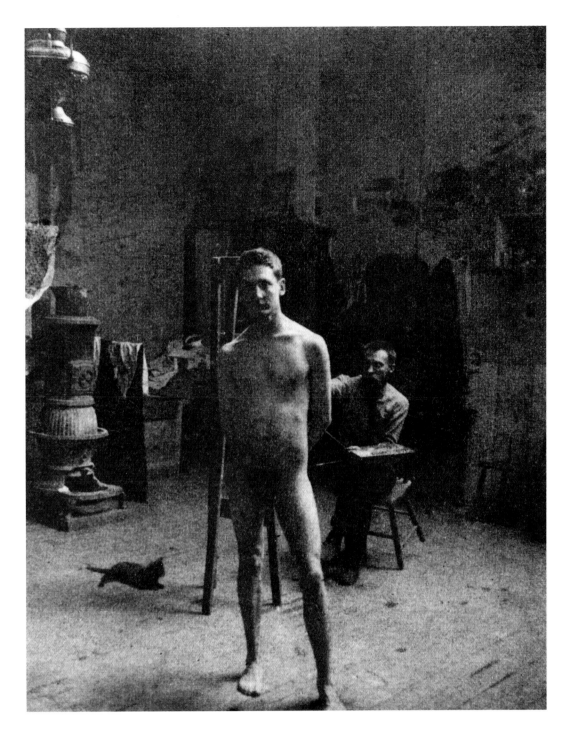

John Wright Posing for George Reynolds, ca. 1889.

George Reynolds painting in the studio of the
Art Students League of Philadelphia, 1338 Chestnut Street.

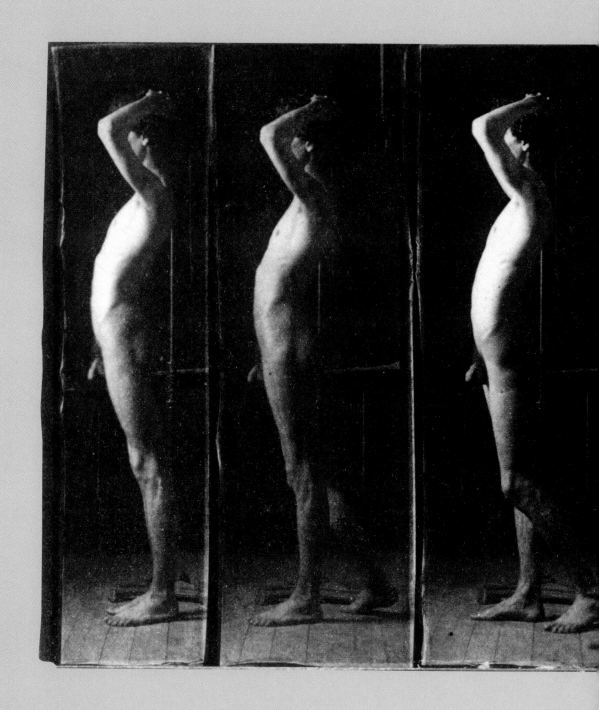

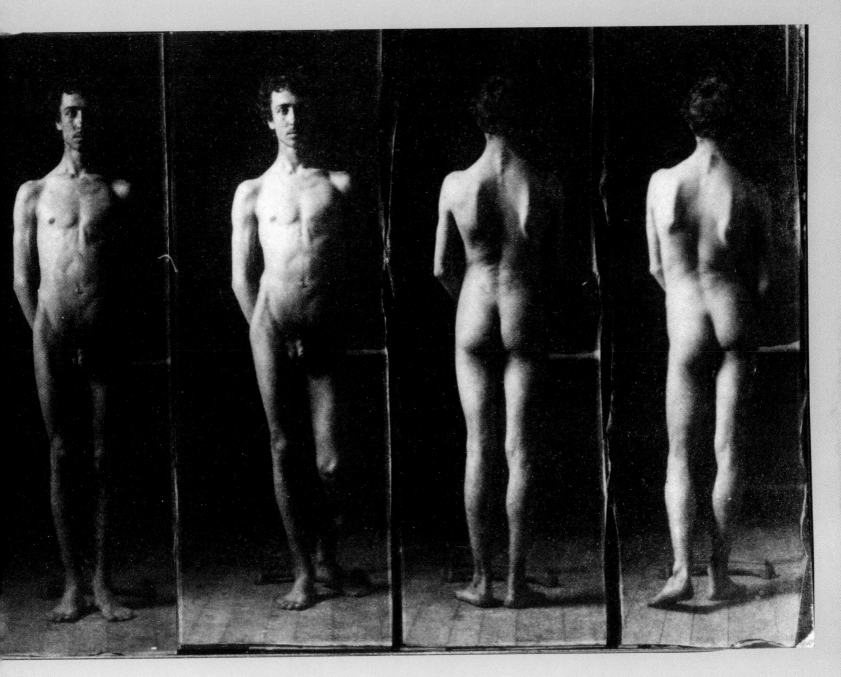

CIRCLE OF THOMAS EAKINS, *Naked Series: John Laurie Wallace,* ca. 1883.

In early 1883, Eakins and a select group of his students began taking sequential
photographs of nude figures in static poses, which he called the "naked series," to use
as a reference in his life classes. John Laurie Wallace was a student of Eakins at the
Pennsylvania Academy of the Fine Arts and at the Art Students League of Philadelphia.

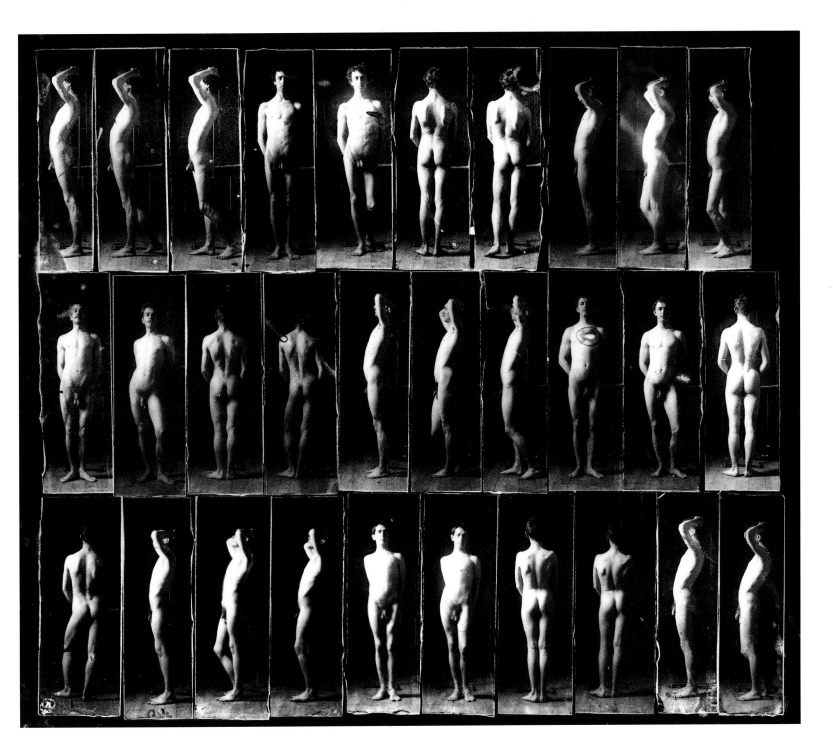

Naked Series, ca. 1883.

In this series of thirty images, Eakins's student John Laurie Wallace posed for seven of
the photographs that appear on the top row, left-hand side of the card. The first four photographs placed
in the middle row, left-hand side of the card, are of another student, Samuel Murray.

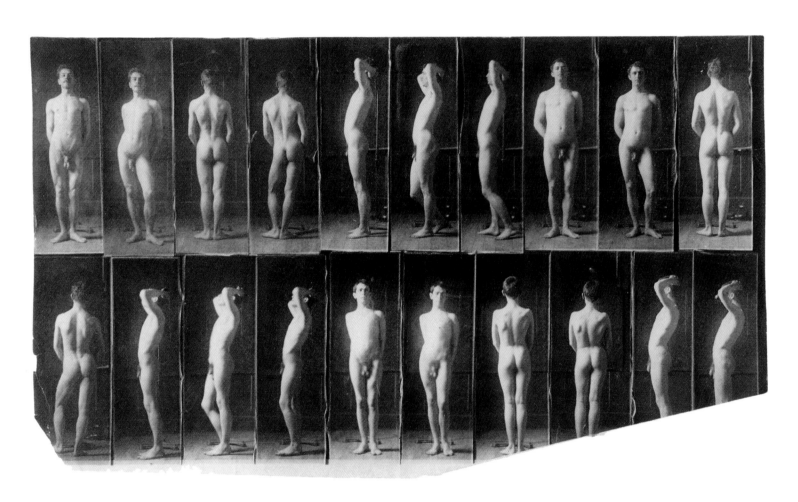

CIRCLE OF THOMAS EAKINS, *Naked Series: Four Male Models*, ca. 1883.

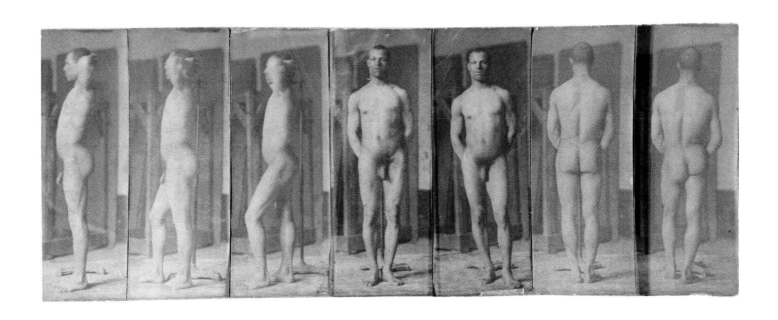

CIRCLE OF THOMAS EAKINS, *Naked Series: African-American Model,* ca. 1883.

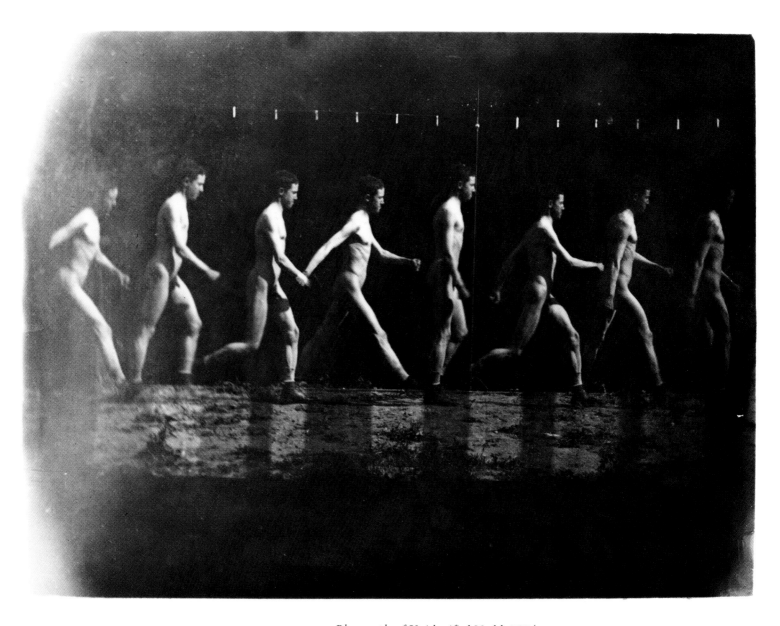

MAREY WHEEL *Photographs of Unidentified Model,* 1884.

To understand the anatomy of a figure in motion, Eakins used a
photographic technique invented by the French scientist Etienne-Jules Marey.

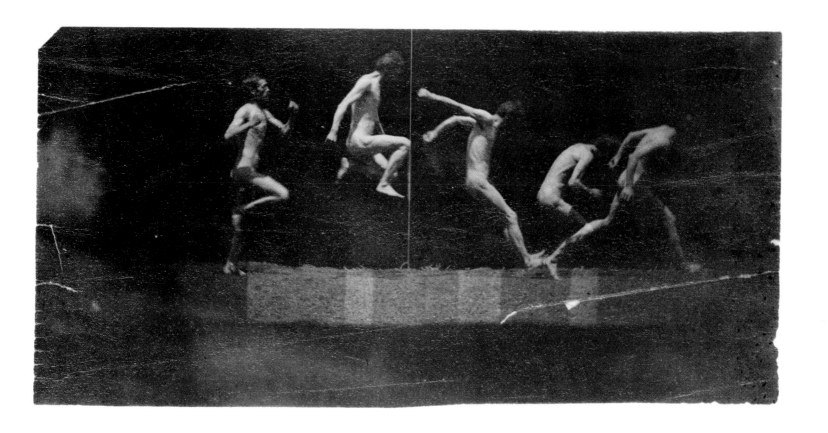

MAREY WHEEL *Photographs of George Reynolds,* 1884.

George Reynolds was a student of Eakins at the
Pennsylvania Academy of the Fine Arts and the Art Students League of Philadelphia,
where he was the first curator of the cooperative organization.

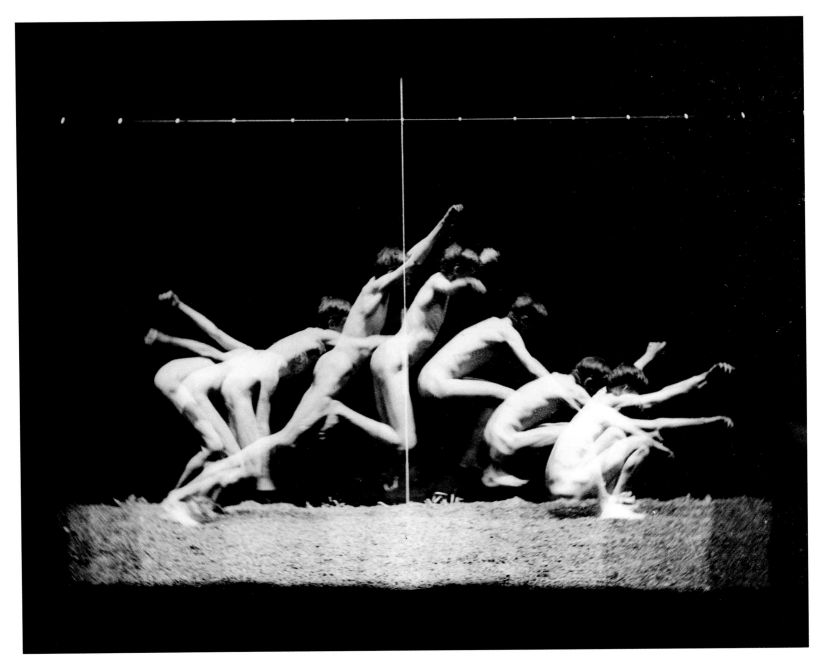

MAREY WHEEL, *Motion Study: Male Nude, Standing Jump to Right,* ca. 1885.

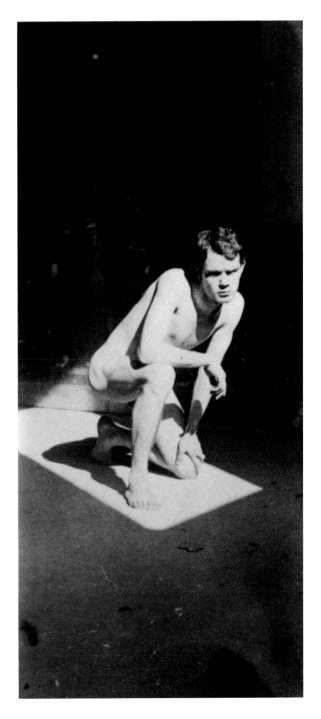

Male Nude Crouching in Sunlit Rectangle in
Pennsylvania Academy of Fine Arts Studio, ca. 1885.

The model appears to be the same one as in Eakins's motion study photograph
(opposite) taken at the University of Pennsylvania.

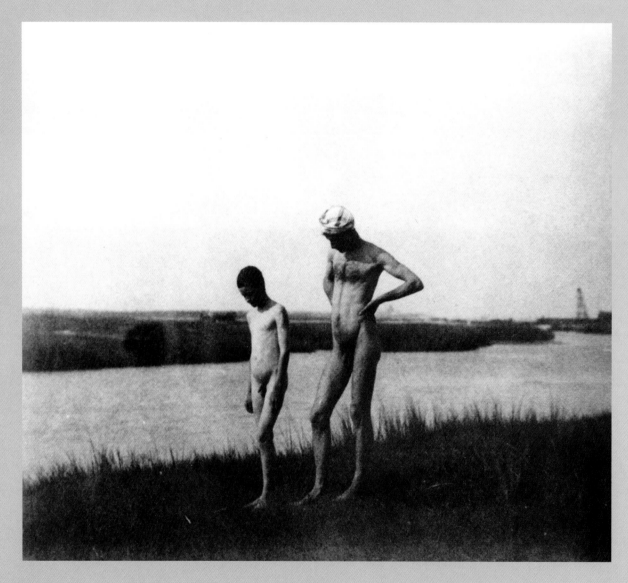

Male Nude Wearing Head Scarf and Boy Nude, at Edge of a River, ca. 1882.

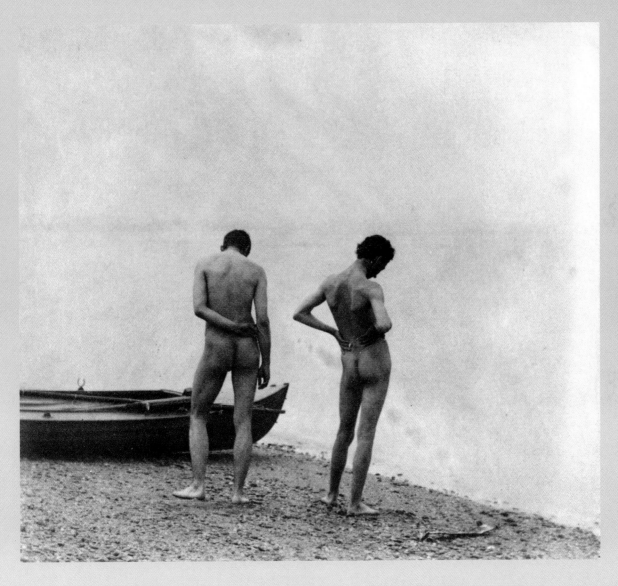

CIRCLE OF THOMAS EAKINS, *Thomas Eakins and John Laurie Wallace,* ca. 1883.

Eakins and his student John Laurie Wallace
posing along Manasquan Inlet at Point Pleasant, New Jersey.

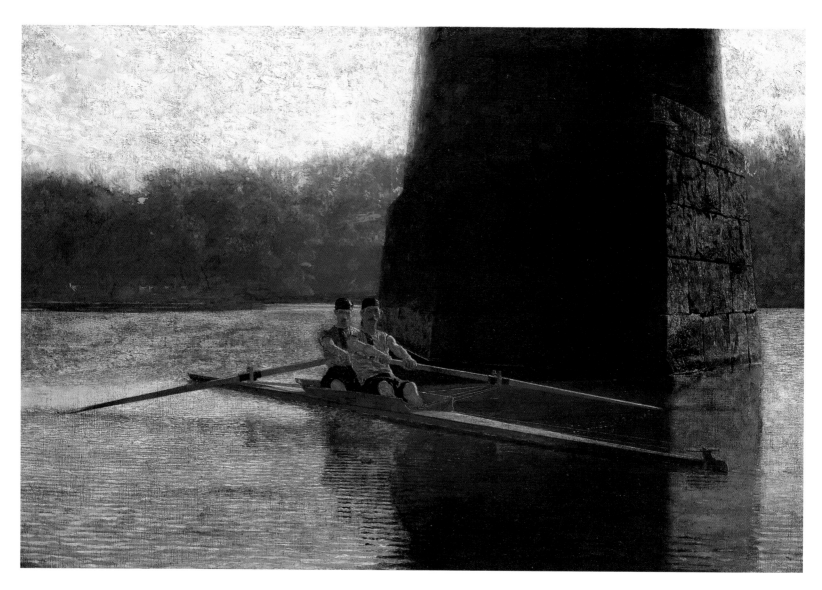

The Pair-Oared Shell, 1872.

Eakins's rowing paintings demonstrated further his preoccupation with the human figure.
The seminude, muscular oarsmen were the perfect theme for his first sporting pictures.

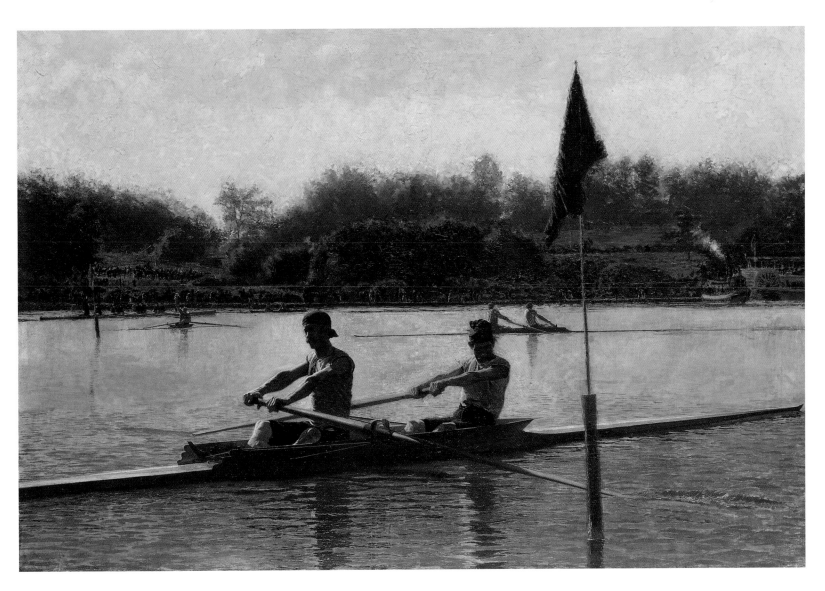

The Biglin Brothers Turning the Stake-Boat, 1873.

John and Bernard Biglin, who hailed from New York City, were the most celebrated oarsmen
in America. Eakins portrayed the men practicing beneath the stone pillar of the
Columbia Rail Road Bridge (opposite) and competing in the first pair-oared contest in the country
(above) on the Schuylkill River in Philadelphia. The brothers won the five-mile contest.

Perspective Study of Baseball Players, ca. 1875.

Eakins's perspective sketch of two baseball
players in motion precisely calculates the depth of
the players in space.

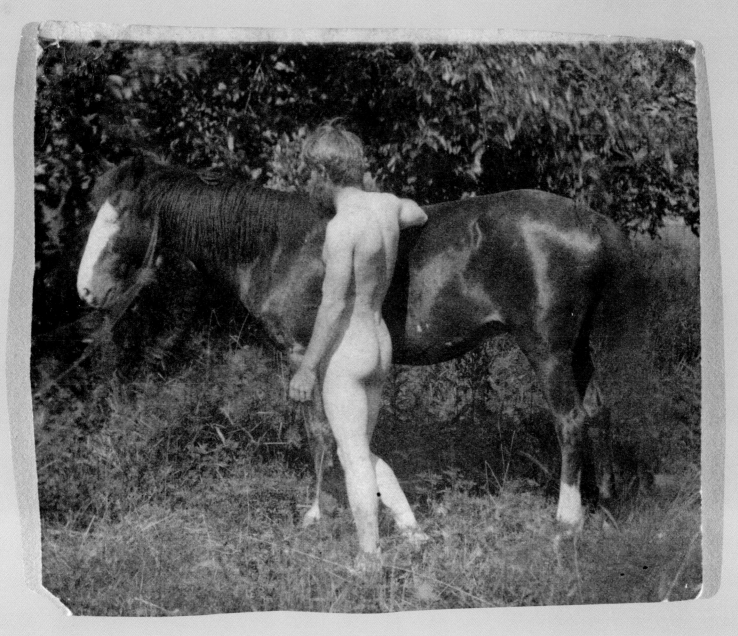

Franklin L. Schenck, with Eakins's Horse "Baldy," ca. 1890.

Franklin Schenck studied with Eakins at the Art Students League of Philadelphia and was
the second curator of the group. Eakins's horse was one of the Western ponies he brought
back with him after a ten-week visit to the B-T ranch, in the Dakota Territory in 1887.

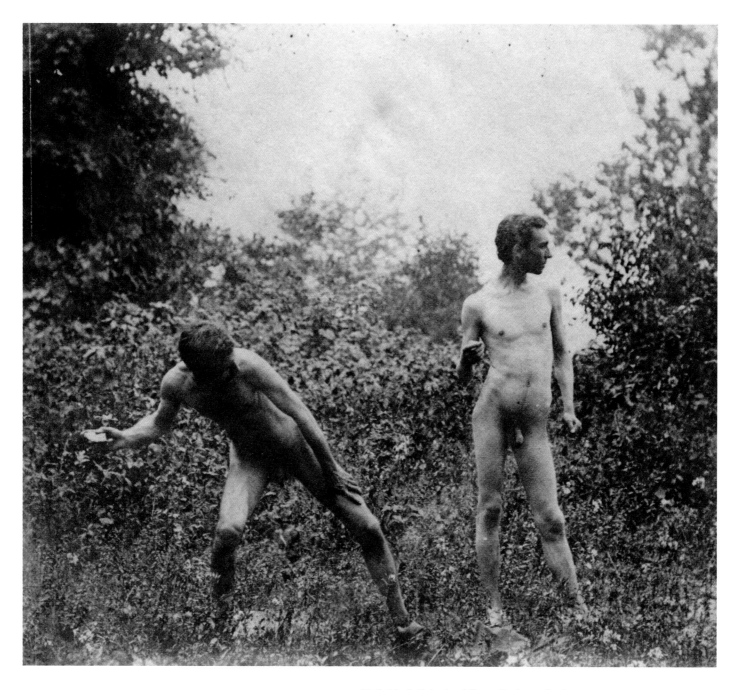

CIRCLE OF THOMAS EAKINS, *Male Nude Poised to Throw Rock, and John Laurie Wallace, in a Wooded Landscape,* 1883.

Eakins posed and photographed the two men in a secluded spot
near Point Pleasant, New Jersey.

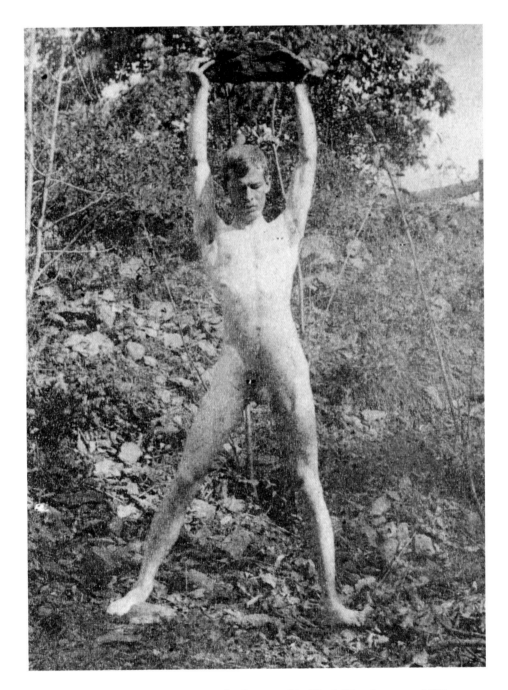

Male Nude, Holding Large Rock Above Head in Wooded Landscape, ca. 1883.

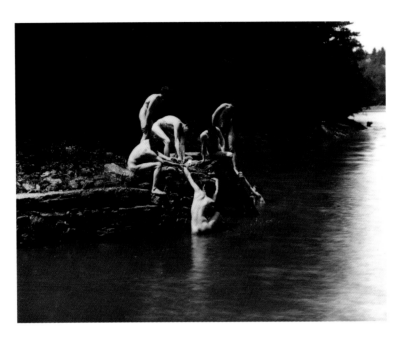

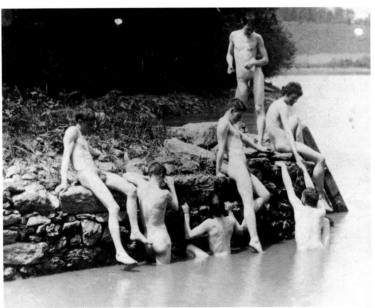

CIRCLE OF THOMAS EAKINS
Male Nudes at the Site of "Swimming," 1883.

Eakins has been tentatively identified as the swimmer pulling himself
out of the water on the far right of the bottom photograph.

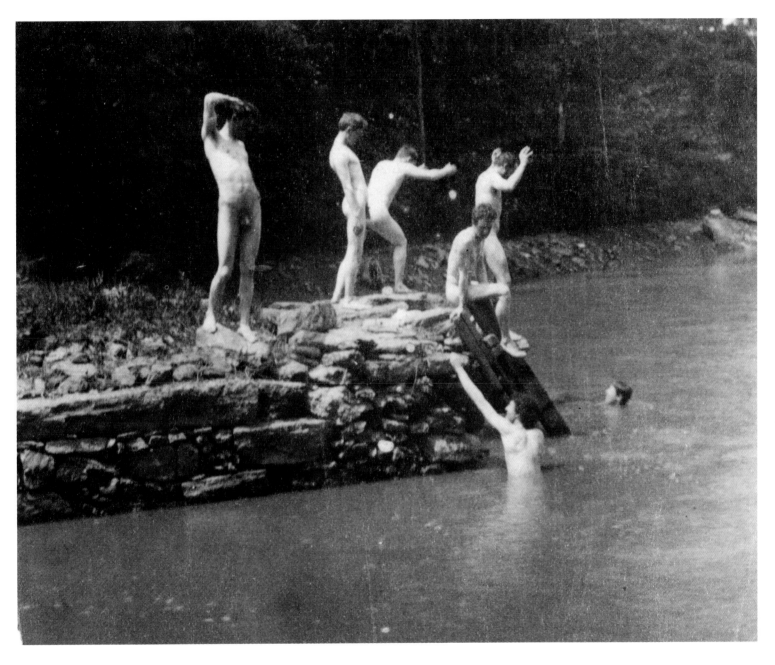

CIRCLE OF THOMAS EAKINS, *Male Nudes at the Site of "Swimming."* 1883.

For one of his rare commissioned works, Eakins made painted studies and photographed five males skinny-dipping on the rock foundation of a mill ruin on Dove Lake, outside of Philadelphia. Four of the men in the bucolic scene were his students. He also included a portrait of himself in the lower right corner of the composition, along with his dog "Harry," paddling toward the shore.

The essence of the painting evokes some of the imagery in *Leaves of Grass*, a poem by Eakins's friend Walt Whitman, of young men bathing:

> The beards of the young men glisten'd with wet,
> > it ran from their long hair,
> Little streams pass'd all over their bodies.
>
> An unseen hand also pass'd over their bodies,
> It descended tremblingly from their temples and ribs.
>
> The young men float on their backs, their white bellies bulge to the sun,
> > they do not ask who seizes fast to them,
> They do not know who puffs and declines with pendant and bending arch,
> They do not think whom they souse with spray.

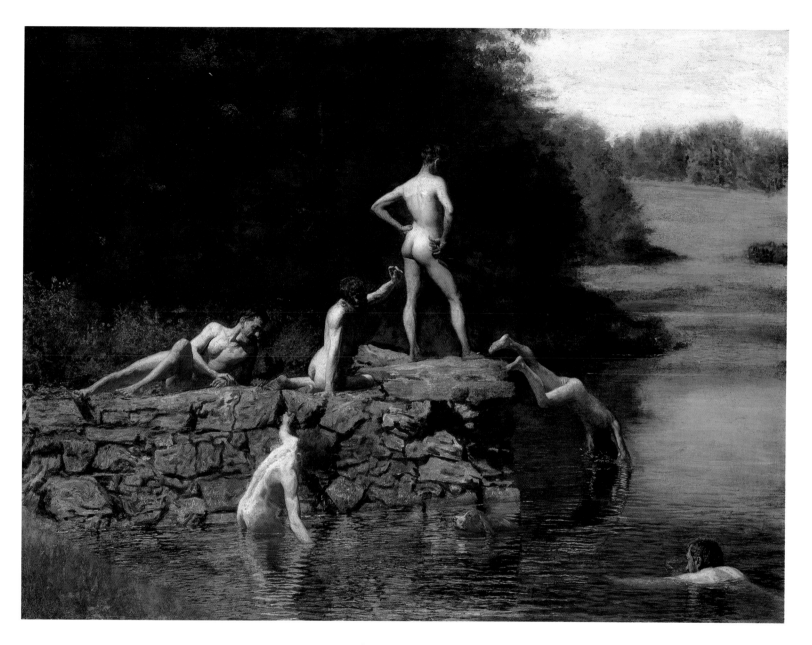

Swimming, 1885.

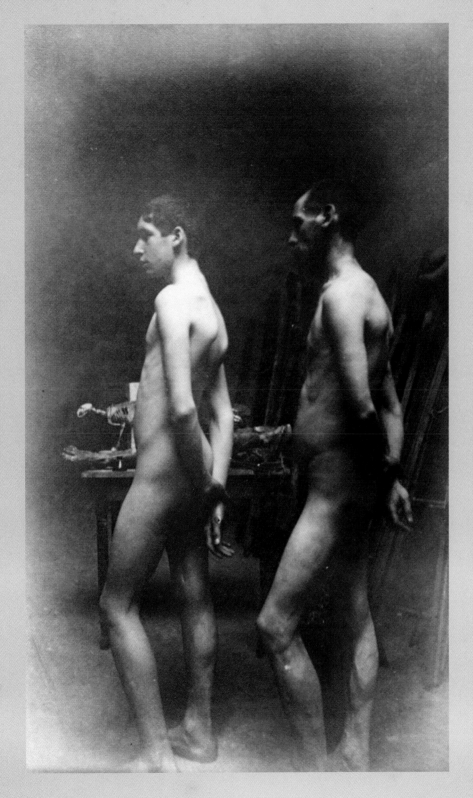

CIRCLE OF THOMAS EAKINS, *Male Students Posing at the Art Students League of Philadelphia*, 1886.

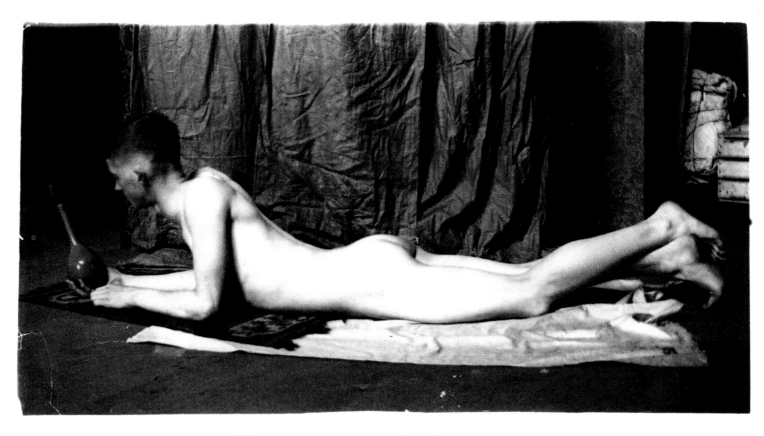

Bill Duckett Nude, Lying on Stomach, Holding Vase, ca. 1889.

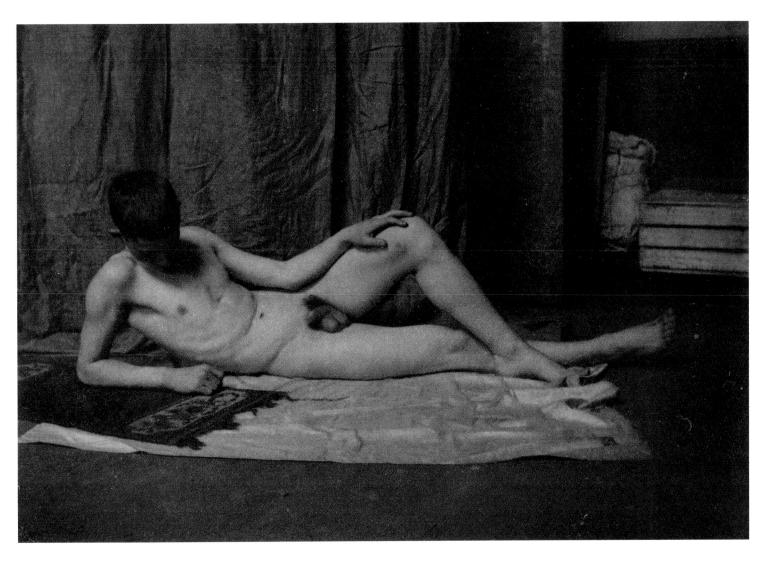

Bill Duckett Nude, Reclining on Side, Hand on Knee, ca. 1889.

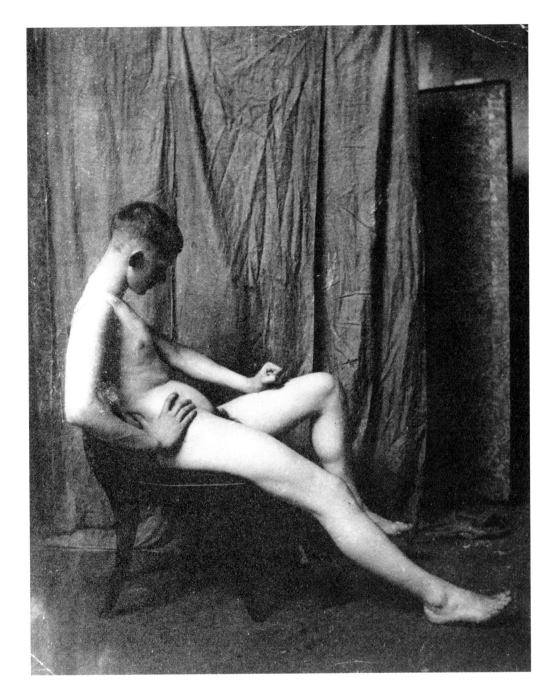

Bill Duckett Nude, Sitting in Chair, ca. 1889.

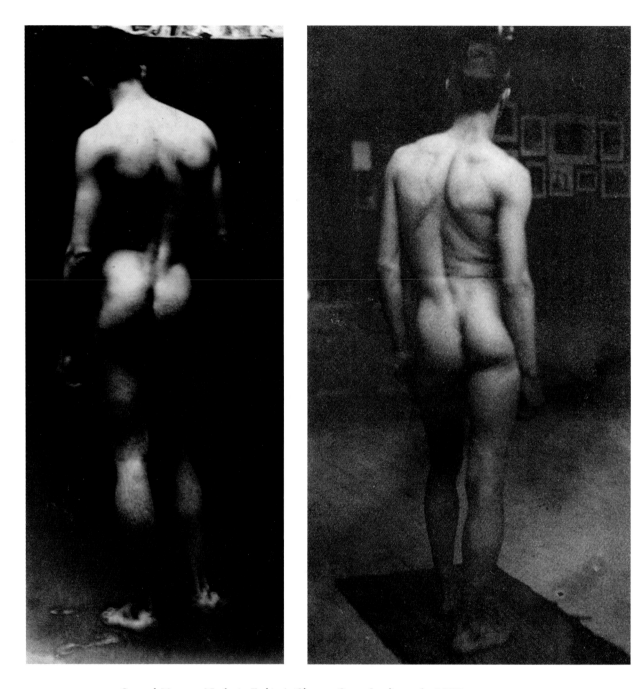

Samuel Murray, Nude, in Eakins's Chestnut Street Studio, early 1890s.

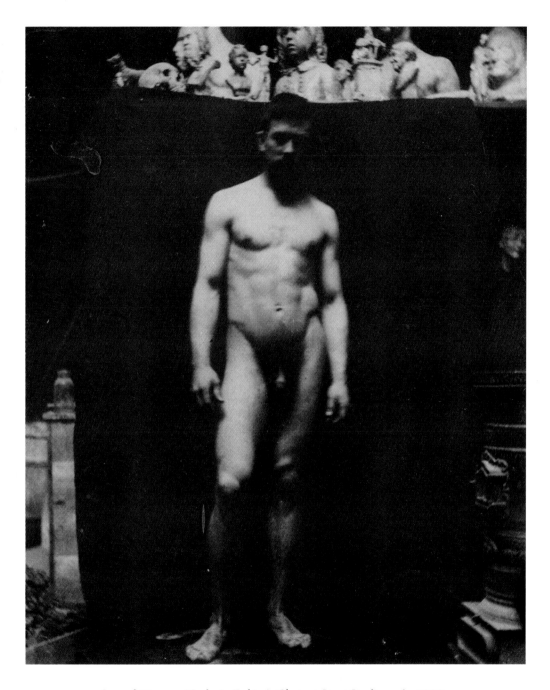

Samuel Murray, Nude, in Eakins's Chestnut Street Studio, early 1890s.

Samuel Murray was a sculptor and former student at the Art Students League of Philadelphia who shared studio space with Eakins at 1330 Chestnut Street. Murray maintained a close relationship with his mentor until the artist's death in 1916.

The crowded amphitheater of the Philadelphia Arena, located diagonally across Broad Street from the Pennsylvania Academy, is the site of Eakins's first prizefighting painting. He placed in the ring the almost life-size figures of Charlie McKeever (standing) who has just knocked down his opponent, Joe Mack, while the referee, Henry Walter Schlichter, is counting. The large canvas was never exhibited to the public during the artist's lifetime.

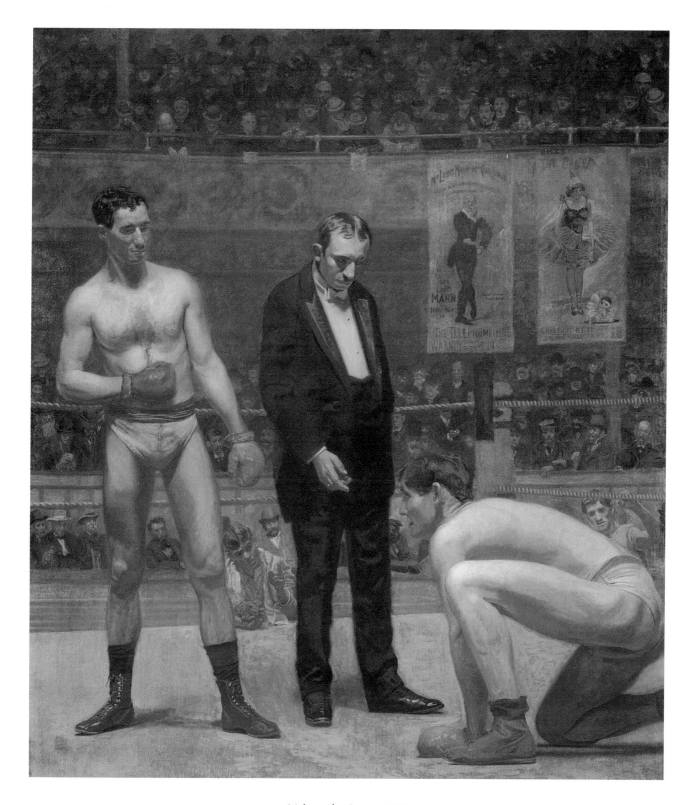

Taking the Count, 1898.

CIRCLE OF THOMAS EAKINS
Male Students Posing at the Art Students League
of Philadelphia, 1886.

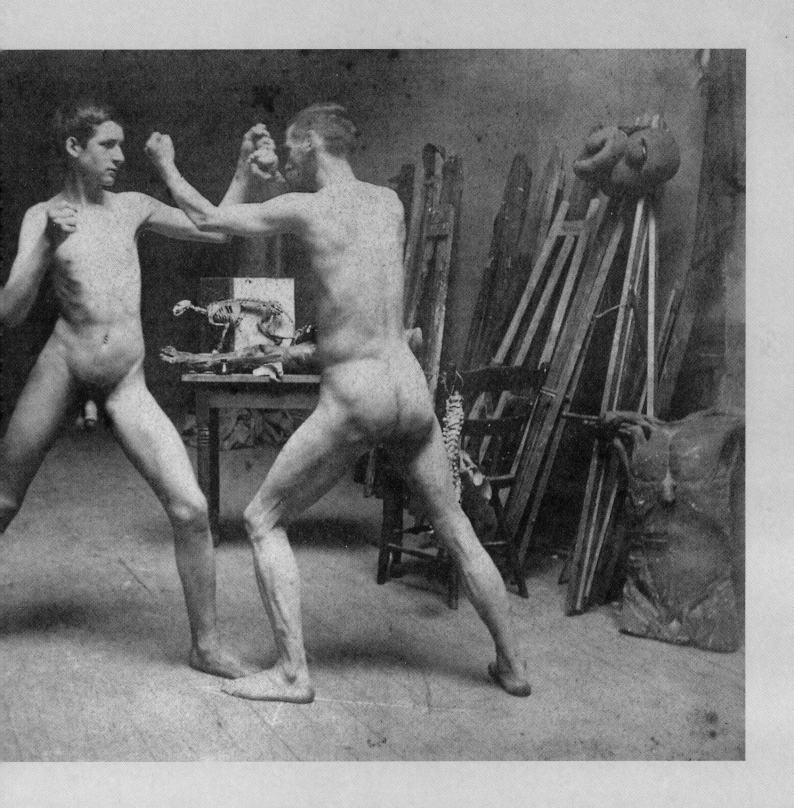

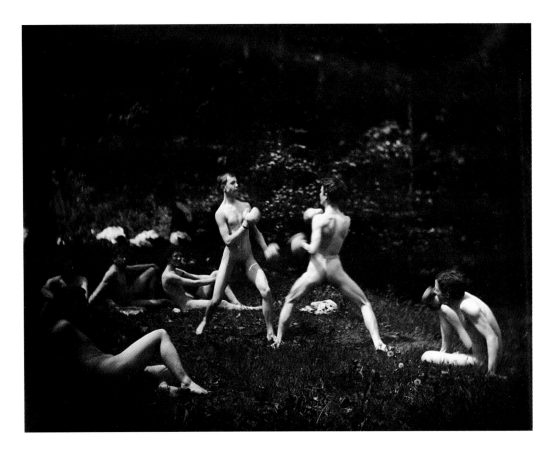

Seven Male Nudes, Two Boxing, ca 1883.

Eakins photographed his students from the Pennsylvania Academy of the Fine Arts
boxing in a secluded outdoor location.

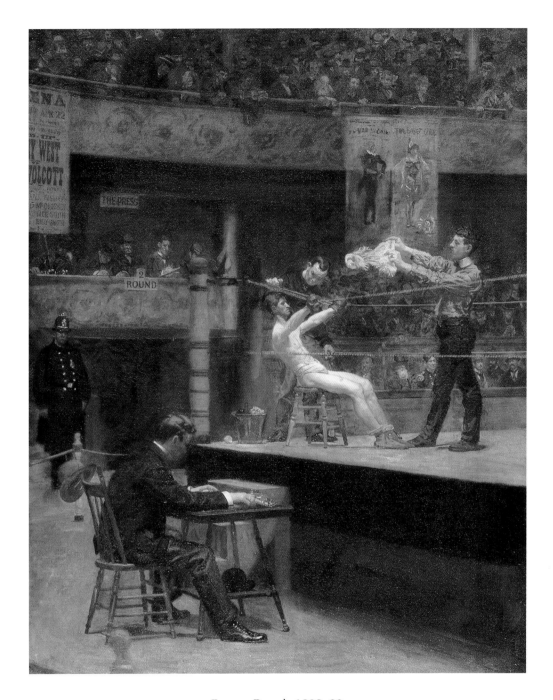

Between Rounds, 1898–99.

Eakins depicted the professional boxer Billy Smith being revived between rounds during a match that he invented at the Philadelphia Arena. A poster announcing the event (April 22, 1898) between Smith and his opponent, Tim Callahan, hangs in the upper left corner of the painting. Eakins placed his friend, sportswriter Clarence Cranmer, as the timekeeper for the match, sitting in the foreground of the composition.

A triumphant Billy Smith raises his arm to salute the exuberant audience at the Philadelphia Arena. In his third boxing painting, Eakins included portraits of the sports reporter Clarence Cranmer waving his hat, and his father Benjamin Eakins seated in the second row on the far right of the bleachers. The artist carved the Latin inscription on the original frame of the painting: *Dextra Victrice Conclamantes Salutat* ("With his right hand the victor salutes those acclaiming him.").

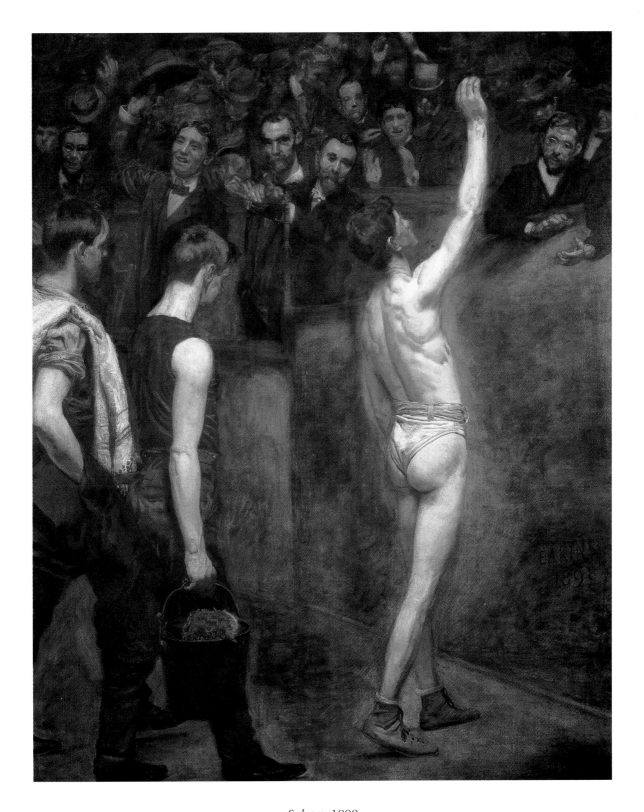

Salutat, 1898.

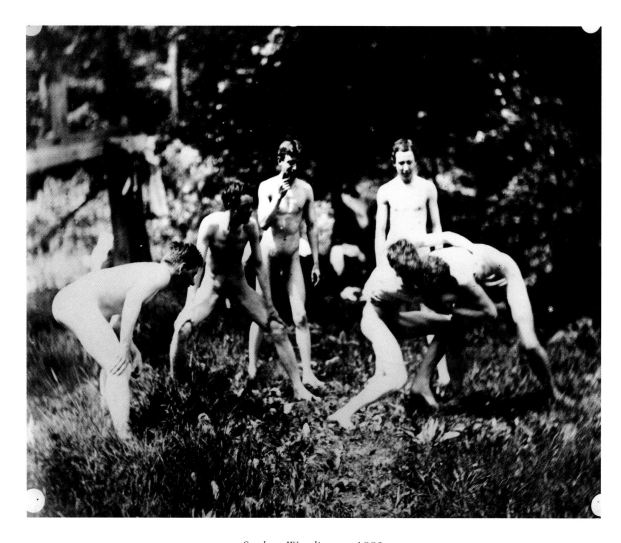

Students Wrestling, ca. 1883.

Eakins photographed his students during an outdoor wrestling match.

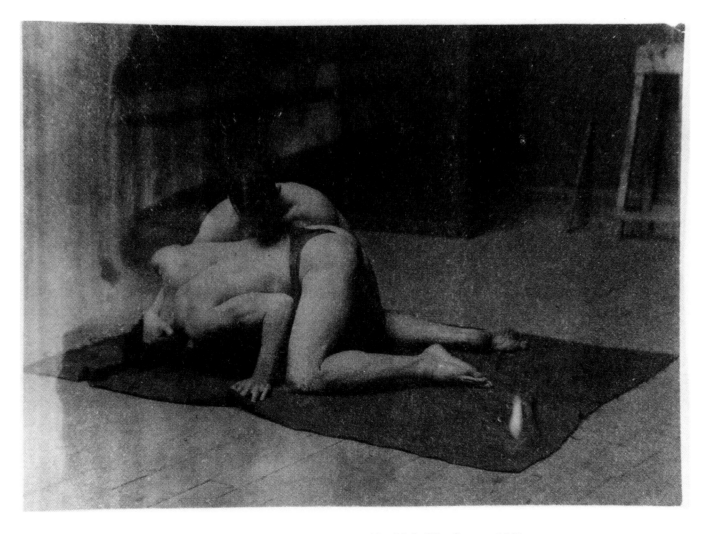

CIRCLE OF THOMAS EAKINS, *Two Males Wrestling,* ca. 1892.

The studio at the Art Students League of Philadelphia is probably where Eakins photographed these
wrestlers from the Quaker City Athletic Club.

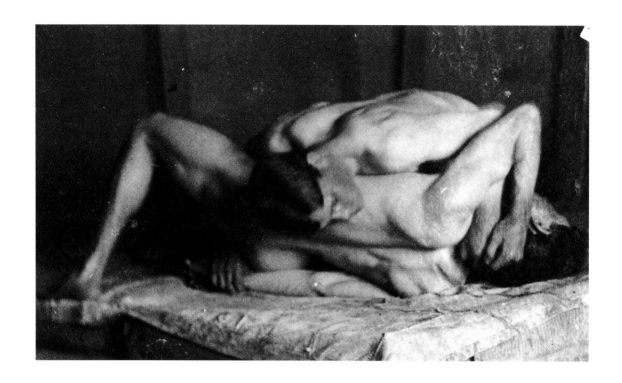

Wrestlers, 1899.

While studying in Paris, Eakins realized that he learned more about the human figure by observing
and sketching his classmates wrestling together than he did from drawing antique casts or posed models.

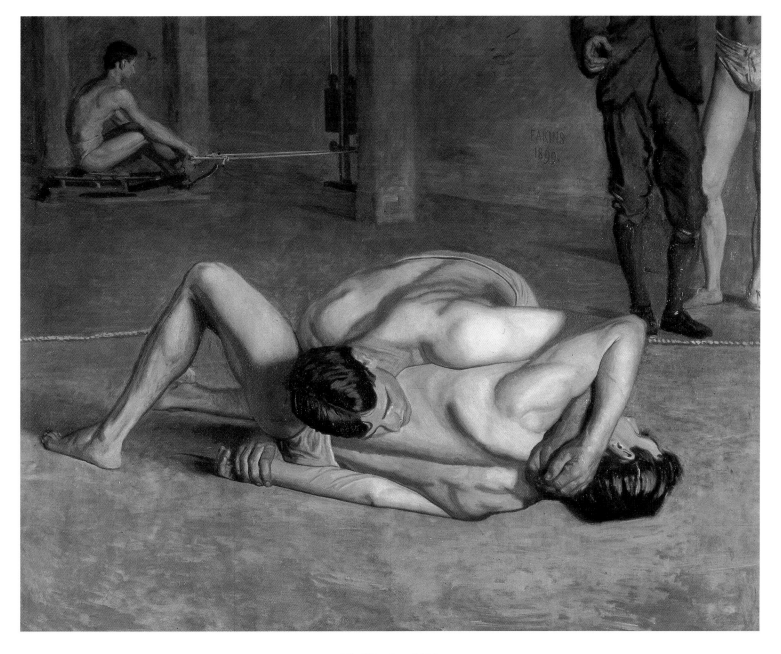

The Wrestlers, 1899.

It is clear that Eakins studied and photographed wrestlers in the gymnasium at the
Quaker City Athletic Club as an exact visual reference for the painting.

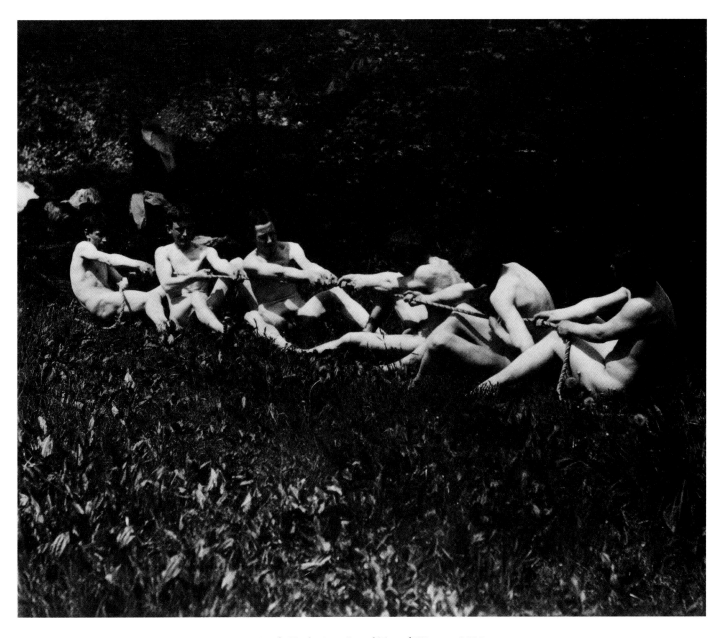

Male Nudes in a Seated Tug-of-War, ca. 1883.

Eakins photographed his students from the Academy of the Fine Arts
playing tug-of-war in an outdoor location.

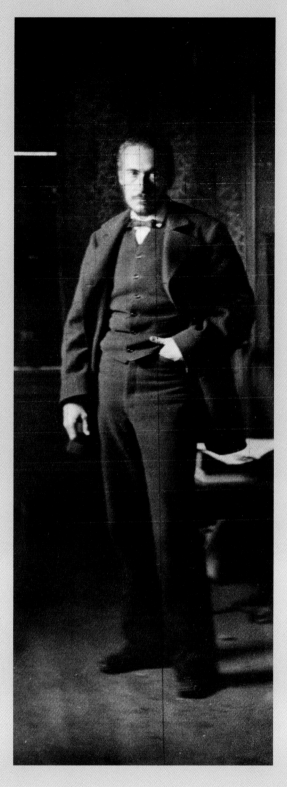

CIRCLE OF THOMAS EAKINS, *Thomas Eakins at about Age Forty,* 1880s.

The grid was added to the photograph of Eakins,
presumably to enlarge and transfer the image onto a canvas.

CHRONOLOGY

1844
Thomas Cowperthwait Eakins born July 25 at
4 Carrolton Square (now 539 Tenth Street) in
Philadelphia, the first child of Benjamin Eakins
and Caroline Cowperthwait Eakins. Benjamin
Eakins was a writing master by profession.

1853
At age nine, Eakins begins attending Zane Street
Grammar School.

1857
Benjamin Eakins buys a red-brick house at 1725
Washington Court (now 1729 Mount Vernon
Street). Eakins successfully passes the stringent
entrance examination to be admitted into Central
High School.

1861
Graduates with honors and receives a bachelor of
arts degree from Central High School.

1862
Registers for drawing and to attend anatomy classes
at the Pennsylvania Academy of the Fine Arts.

1863
Admitted into the life drawing classes at the
Pennsylvania Academy.

1864
Attends Dr. Joseph Pancoast's anatomy lectures at
Jefferson Medical College in Philadelphia.

1866
Goes to Paris, where he is accepted into Jean-Léon
Gérôme's class at the Ecole des Beaux-Arts.
Eakins becomes the artist/teacher's second
American student.

1869–1870
Travels to Spain where he paints and studies the
work by Velásquez in the Prado, Madrid. Returns
to Philadelphia on July 4, 1870 and begins paint-
ing in a studio he arranged on the top floor of his
family's Mount Vernon Street home.

1872
Paints the *Pair-Oared Shell,* the first oil that
featured the Biglin brothers rowing on the
Schuylkill River in Fairmount Park.

1874
Attends Dr. Samuel Gross's surgical demonstra-
tions at Jefferson Medical College. Begins the fol-
lowing year a portrait of Dr. Gross standing in the
operating amphitheater of the school.

1876
Teaches part-time at the Pennsylvania Academy,
assisting Christian Schussele in his drawing and
painting classes and in Dr. William Williams
Keen's anatomy classes.

1880
Acquires his first camera and experiments with
photography

1882

Named director of the Pennsylvania Academy of the Fine Arts.

1884

Edward Coates, chairman of the committee on instruction at the Pennsylvania Academy, commissions *Swimming*, which he later rejects. Marries Susan Macdowell, a student at the Pennsylvania Academy. Assists Eadweard Muybridge with his photographic experiments of animal locomotion at the University of Pennsylvania.

1886

During a lecture to a class of female students at the Pennsylvania Academy, Eakins removes the loincloth from a male model. Subsequently he is asked to resign from the school. Thirty-eight of his students resign in protest and establish the Art Students League of Philadelphia.

1887

Visits Walt Whitman at his home in Camden, New Jersey, where he photographs and paints the poet's portrait.

1893

The Art Students League of Philadelphia is dissolved.

1898

Completes his first boxing painting, *Taking the Count*. The large canvas was never exhibited to the public during his lifetime.

1902

Elected an associate of the National Academy of Design and, two months later, an academician.

1916

Eakins dies on June 25 at 1729 Mount Vernon Street.

1917

The Metropolitan Museum of Art and the Pennsylvania Academy of the Fine Arts mount memorial exhibitions of Eakins's work.

NOTES

[1] Thomas Eakins to Edward Coates, September 11, 1886, in *Writing about Eakins: The Manuscripts in Charles Bregler's Thomas Eakins Collection,* Kathleen A. Foster and Cheryl Leibold, (University of Pennsylvania Press for Pennsylvania Academy of the Fine Arts) 1989, p. 237.

[2] Lloyd Goodrich, *Thomas Eakins, His Life and Early Work,* (Whitney Museum of American Art, New York), 1933.

[3] Ibid.

[4] Microfilm, roll p71, frame 878, Archives of American Art. Quoted in Anne McCauley, *Eakins and the Photograph,* (Pennsylvania Academy of the Fine Arts, Smithsonian Press, Washington and London) 1994, p. 38.

[5] Darrell Sewell, *Thomas Eakins, Artist of Philadelphia,* (Philadelphia Museum of Art) 1982, p. 82.

[6] Anne McCauley, *Eakins and the Photograph,* (Pennsylvania Academy of the Fine Arts, Smithsonian Press, Washington and London) 1994, p. 57.

[7] Earl Shinn, "A Philadelphia Art School," *Art Amateur* 10, January 1884.

[8] Thomas Eakins to Benjamin Eakins, May 1868. Quoted in Lloyd Goodrich, *Thomas Eakins,* (National Gallery of Art, Harvard University Press, Cambridge), 1982.

[9] Horace Traubel, *With Walt Whitman in Camden,* (Small, Maynard & Company, Boston) 1906, p. 284.

SELECT BIBLIOGRAPHY

Barker, Virgil, *American Painting: History and Interpretation.* New York: Bonanza Books, 1960.

Benjamin, S. G. W. *Art in America: A Critical and Historical Sketch.* New York: Harper and Brothers, 1880.

Berger, Martin. *Man Made, Thomas Eakins and the Construction of Gilded Age Manhood.* Berkeley, Los Angeles, and London: University of California Press, 2000.

Brownell, William C. "The Art Schools of Philadelphia." *Scribner's Monthly Magazine* 18. September 1879.

Canaday, John. *The Mainstreams of Modern Art.* New York: Simon and Schuster, 1959.

Danley, Susan and Cheryl Leibold, et al. *Eakins and the Photograph, Works by Thomas Eakins and His Circle in the Pennsylvania Academy of the Fine Arts.* Washington, London: Smithsonian Institute Press, 1994.

Erdman, David V., Ed. *The Complete Poetry and Prose of William Blake.* New York, 1988, p. 13.

Foster, Kathleen A., and Cheryl Leibold. *Writing about Eakins: The Manuscripts in Charles Bregler's Thomas Eakins Collection.* Philadelphia: University of Pennsylvania Press, 1989.

Goodrich, Lloyd. *Thomas Eakins, His Life and Work.* New York: Whitney Museum of American Art, 1933.

_____. *Thomas Eakins.* New York: Whitney Museum of American Art, 1970.

Hendricks, Gordon. *The Photographs of Thomas Eakins.* New York: Grossman Publishers, 1972.

Johns, Elizabeth. *Thomas Eakins: The Heroism of Modern Life.* New York: Princeton University Press, 1983.

McKinney, Roland. *Thomas Eakins.* New York: Crown Publishers, 1942.

Porter, Fairfield. *Thomas Eakins.* New York: George Braziller, Inc., 1959.

Rosenzweig, Phyllis D. *The Thomas Eakins Collection at the Hirshhorn Museum and Sculpture Garden.* Washington, D.C.: Smithsonian Institute Press, 1977.

Sewell, Darrell. *Thomas Eakins, Artist of Philadelphia.* Philadelphia Museum of Art, 1982.

Shinn, Earl. "A Philadelphia Art School," *Art Amateur* 10, January 1884.

Traubel, Horace. *With Walt Whitman in Camden.* Boston: Small, Maynard & Company, 1906.

Whitman, Walt. *Leaves of Grass.* New York: Modern Library Edition, following the arrangement of the edition of 1891–2.

ILLUSTRATIONS

Numbers refer to pages on which illustrations appear. All works are by Thomas Eakins unless otherwise noted.

ENDPAPERS AND PAGES 40–41: *Perspective Drawing of Baseball Players,* ca. 1875. Pencil on paper, 13 ¹⁵⁄₁₆ x 17 ¹⁄₁₆ inches. Hirshhorn Museum and Sculpture Garden, Washington, D.C.

OPPOSITE TITLE PAGE: Susan Macdowell Eakins, *Portrait of Thomas Eakins,* ca. 1920–25. Oil on canvas, 50 x 40 inches. Philadelphia Museum of Art. Gift of Charles Bregler.

5. *Figure Study: Two Knees,* ca. 1863–66. Charcoal on paper, 24 x 18 ¹⁄₁₆ inches. Pennsylvania Academy of the Fine Arts, Philadelphia. Charles Bregler's Thomas Eakins Collection, purchased with the partial support of the Pew Memorial Trust and the John S. Phillips Fund.

8. *John Wright Posing at the Art Students League of Philadelphia,* ca. 1886–92. Copyprint of a photograph lent by Dr. Henry Ritter. Metropolitan Museum of Art, New York City, David Hunter McAlpin Fund, 1943.

11. *Tom Eagan, in Front of Folding Screen,* ca. 1889. Print, 4 ¹³⁄₁₆ x 3 ³⁄₁₆ inches. Pennsylvania Academy of the Fine Arts, Philadelphia. Charles Bregler's Thomas Eakins Collection, purchased with partial support of the Pew Memorial Trust.

12. Walter M. Dunk, *The Male Life Class,* ca. 1879. Oil on cardboard (grisaille), 10 ¼ x 12 ¾ inches. Pennsylvania Academy of the Fine Arts, Philadelphia. Gift of the artist.

14. Alice Barber Stephens, *The Women's Life Class,* ca. 1879. Oil on cardboard (grisaille), 12 x 14 inches. Pennsylvania Academy of the Fine Arts, Philadelphia. Gift of the artist.

15. Charles H. Stephens, *Anatomical Lecture by Dr. William Williams Keen,* ca. 1879. Oil on cardboard (grisaille), 8 ⅝ x 11 inches. Pennsylvania Academy of the Fine Arts, Philadelphia. Gift of the artist.

17. *Photograph at the Art Students League of Philadelphia,* 1886–1892. Albumen print, 9 x 7 ⁷⁄₁₆ inches. Charles Bregler archival collection, Hirshhorn Museum and Sculpture Garden, Washington, D.C.

18. *Plan and Perspective Study of the Artist's Signature:* [for] *Portrait of Dr. John H. Brinton* (detail), 1876. Pen and ink over graphite on foolscap, 13 ⅞ x 17 ¹⁄₁₆ inches. Pennsylvania Academy of the Fine Arts, Philadelphia. Charles Bregler's Thomas Eakins Collection, purchased with the partial support of the Pew Memorial Trust and the John S. Phillips Fund.

19. Charles Fussell, *Life Study (Young Art Student—Sketch of Thomas Eakins),* ca. 1865–66. Oil on paper, 15 x 12 ¾ inches. Philadelphia Museum of Art, Gift of Seymour Adelman.

20–21. Charles Truscott, *Cast Drawing Room at the Pennsylvania Academy,* ca. 1890s. Platinum print, 7 x 9 ½ inches. Pennsylvania Academy of the Fine Arts, Philadelphia. Archives.

22. *Study of a Nude Man (The Strong Man),* ca. 1869. Oil on canvas, 21 ½ x 17 ⅝ inches. Philadelphia Museum of Art. Gift of Mrs. Thomas Eakins and Miss Mary Adeline Williams, 1929.

23. *Bust of a Nude Man,* ca. 1869. Oil on canvas, 21 ½ x 18 ¼ inches. Philadelphia Museum of Art. Gift of Mrs. Thomas Eakins and Miss Mary Adeline Williams, 1929.

24. *Man Seated, Hands Clasped Around Crossed Knees,* ca. 1874–76. Charcoal on paper, 24 ⁵⁄₁₆ x 18 ½ inches. Philadelphia Museum of Art. Gift of Mrs. Thomas Eakins and Miss Mary Adeline Williams, 1929.

25. *John Wright Posing for George Reynolds* ca. 1889. Cyanotype, 4 ½ x 3 ⁹⁄₁₆ inches. Pennsylvania Academy of the Fine Arts, Philadelphia. Charles Bregler's Thomas Eakins Collection, purchased with the partial support of the Pew Memorial Trust.

26–27. Circle of Thomas Eakins, *Naked Series: John Laurie Wallace,* ca. 1883. Seven albumen prints, mounted on cardboard, 3 ⅛ x 7 ⅞ inches. Philadelphia Museum of Art. Purchased with the Smith Kline Beckman (now Smith Kline Beechman) fund for the Arts Medica Collection, 1984.

29. *Naked Series,* ca. 1883. Thirty albumen prints, mounted on cardboard, 10 x 12 inches, contact print from original negative. The Historical and Interpretive Collections of the Franklin Institute, Philadelphia.

30. Circle of Thomas Eakins, *Naked Series: Four Male Models,* ca. 1883. Twenty composite albumen prints, 6 ½ x 11 ⅛ inches. Pennsylvania Academy of the Fine Arts, Philadelphia. Charles Bregler's Thomas Eakins Collection, purchased with the partial support of the Pew Memorial Trust.

31. Circle of Thomas Eakins, *Naked Series: African-American Male,* ca. 1883. Seven albumen prints mounted on cardboard, each approximately 3 ⅟₁₆ x 8 ⅜ inches. Pennsylvania Academy of the Fine Arts, Philadelphia. Charles Bregler's Thomas Eakins Collection, purchased with the partial support of the Pew Memorial Trust.

32. Marey Wheel, *Photographs of Unidentified Model,* 1884. Albumen print, 5 x 6 ¾ inches. Philadelphia Museum of Art. Gift of Charles Bregler.

33. Marey Wheel, *Photographs of George Reynolds,* 1884. Albumen print, 2 ⁵⁄₁₆ x 4 ⅟₁₆ inches. Hirshhorn Museum and Sculpture Garden, Washington, D.C.

34. Marey Wheel, *Motion Study: Male Nude, Standing Jump to Right,* ca. 1885. Dry plate negative, 3 ⅜ x 4 ½ inches. Pennsylvania Academy of the Fine Arts, Philadelphia. Charles Bregler's Thomas Eakins Collection, purchased with the partial support of the Pew Memorial Trust.

35. *Male Nude Crouching in Sunlit Rectangle, Pennsylvania Academy of Fine Arts Studio,* ca. 1885. Albumen print, 3 ¹³⁄₁₆ x 1 ⅞ inches. Pennsylvania Academy of the Fine Arts, Philadelphia. Charles Bregler's Thomas Eakins Collection, purchased with the partial support of the Pew Memorial Trust.

36. *Male Nude Wearing Head Scarf, and Boy Nude, at Edge of River,* ca. 1882. Albumen print, 3 ⁹⁄₁₆ x 4 ⅜ inches. Pennsylvania Academy of the Fine Arts, Philadelphia. Charles Bregler's Thomas Eakins Collection, purchased with the partial support of the Pew Memorial Trust.

37. Circle of Thomas Eakins, *Thomas Eakins and John Laurie Wallace* ca. 1883. Albumen print, 3 ½ x 4 inches. Pennsylvania Academy of the Fine Arts, Philadelphia. Charles Bregler's Thomas Eakins Collection, purchased with the partial support of the Pew Memorial Trust.

38. *The Pair-Oared Shell,* 1872. Oil on canvas, 24 x 36 ½ inches. Philadelphia Museum of Art. Gift of Mrs. Thomas Eakins and Miss Mary Adeline Williams, 1929.

39. *The Biglin Brothers Turning the Stake-Boat,* 1873. Oil on canvas, 39 ⅞ x 59 ⅞ inches. Cleveland Museum of Art, Hinman B. Hurlbut Collection.

40–41. *Perspective Drawing of Baseball Players,* ca. 1875. Pencil on paper, 13 ¹⁵⁄₁₆ x 17 ⅟₁₆ inches. Hirshhorn Museum and Sculpture Garden, Washington, D.C.

43. *Franklin L. Schenck with Eakins's Horse "Baldy,"* ca. 1890. Platinum print, 3 ¼ x 3 ¹³⁄₁₆ inches. Pennsylvania Academy of the Fine Arts, Philadelphia. Charles Bregler's

Thomas Eakins Collection, purchased with the partial support of the Pew Memorial Trust.

44. Circle of Thomas Eakins, *Male Nude Poised to Throw Rock, and John Laurie Wallace, in a Wooded Landscape,* 1883. Albumen print, 3 ¾ x 4 ¼ inches. Pennsylvania Academy of the Fine Arts, Philadelphia. Charles Bregler's Thomas Eakins Collection, purchased with the partial support of the Pew Memorial Trust.

45. *Male Nude, Holding Large Rock Above Head, in Wooded Landscape,* ca. 1883. Albumen print, 3 ½ x 2 ⁹⁄₁₆ inches. Pennsylvania Academy of the Fine Arts, Philadelphia. Charles Bregler's Thomas Eakins Collection, purchased with the partial support of the Pew Memorial Trust.

46. (Top) Circle of Thomas Eakins, *Eakins's students at Site of "Swimming,"* 1883. Dry-plate negative, 4 x 5 inches. Pennsylvania Academy of the Fine Arts, Philadelphia. Charles Bregler's Thomas Eakins Collection, purchased with the partial support of the Pew Memorial Trust.

46. (Bottom) Circle of Thomas Eakins, *Thomas Eakins and Students at Site of "Swimming,"* ca. 1883. 6 ⅟₁₆ x 7 ¹³⁄₁₆ inches. Hirshhorn Museum and Sculpture Garden, Washington, D. C.

47. Circle of Thomas Eakins, *Eakins's Students at Site of "Swimming,"* ca. 1883. Albumen print, 6 ⅟₁₆ x 7 ¹³⁄₁₆ inches. Hirshhorn Museum and Sculpture Garden, Washington, D. C.

49. *Swimming,* 1885. Oil on canvas, 27 ⅜ x 36 ⅜ inches. Amon Carter Museum, Fort Worth, Texas. Purchased by the Friends of

Art, Fort Worth Art Association, 1925; acquired by the Amon Carter Museum, 1990, from the Modern Art Museum of Fort Worth through grants and donations from the Amon G. Carter Foundation, the Sid W. Richardson Foundation, the Anne Burnett and Charles Tandy Foundation, Capital Cities/ABC Foundation, *Fort Worth Star Telegram,* The R. D. and Joan Dale Hubbard Foundation, and the people of Fort Worth.

51. Circle of Thomas Eakins, *Male Students Posing at the Art Students League of Philadelphia,* 1886. Albumen print, 7 ⅝ x 4 ⁹⁄₁₆ inches. Sterling and Francine Clark Art Institute, Williamstown, Massachusetts.

52. *Bill Duckett Nude, Lying on Stomach, Holding Vase,* ca. 1889. Platinum print, 2 ¹¹⁄₁₆ x 4 ⅜ inches. Pennsylvania Academy of the Fine Arts, Philadelphia. Charles Bregler's Thomas Eakins Collection, purchased with the partial support of the Pew Memorial Trust.

53. *Bill Duckett Nude, Reclining on Side, Hand on Knee,* ca. 1889. Platinum print, 2 ¹⁵⁄₁₆ x 4 ⁵⁄₁₆ inches. Pennsylvania Academy of the Fine Arts, Philadelphia. Charles Bregler's Thomas Eakins Collection, purchased with the partial support of the Pew Memorial Trust.

55. *Bill Duckett Nude, Sitting in Chair,* ca. 1889. Platinum print, 4 ¼ x 3 ⁷⁄₁₆ inches. Pennsylvania Academy of the Fine Arts, Philadelphia. Charles Bregler's Thomas Eakins Collection, purchased with the partial support of the Pew Memorial Trust.

56. *Samuel Murray, Nude, in Eakins's Chestnut Street Studio,* early 1890s. Left: platinum print, 4 ¹⁄₁₆ x 1 ⅞ inches.

Right: platinum print, 3 ⁷⁄₁₆ x 2 ¹⁄₁₆ inches. Hirshhorn Museum and Sculpture Garden, Smithsonian Institution, Washington, D.C. Transferred from Hirshhorn Museum and Sculpture Garden Archives, 1983.

57. *Samuel Murray, Nude, in Eakins' Chestnut Street Studio,* early 1890s. Cyanotype, 4 ⅜ x 3 ¹¹⁄₁₆ inches. Hirshhorn Museum and Sculpture Garden, Smithsonian Institution, Washington, D.C. Transferred from Hirshhorn Museum and Sculpture Garden Archives, 1983.

59. *Taking the Count,* 1898. Oil on canvas, 96 ¼ x 84 ¼ inches. Yale University Art Gallery, New Haven, Connecticut. Whitney Collection of Sporting Art, given in memory of Harry Payne Whitney, B.A. 1894, and Payne Whitney, B.A. 1898, by Francis P. Garvan, B.A. 1897, M.A. (Hon.) 1922, June 2, 1932.

60–61. Circle of Thomas Eakins, *Male Students posing at the Art Students League of Philadelphia,* 1886. From an album of twenty albumen prints and one gelatin silver print, each approximately 4 ½ by 7 inches. Sterling and Francine Clark Institute, Williamstown, Massachusetts.

62. *Seven Male Nudes Two Boxing,* ca. 1883. Dry plate negative print, 4 x 5 inches. Pennsylvania Academy of the Fine Arts, Philadelphia. Charles Bregler's Thomas Eakins Collection, purchased with the partial support of the Pew Memorial Trust.

63. *Between Rounds,* 1898–1899. Oil on canvas, 50 ¼ x 40 inches. Philadelphia Museum of Art. Gift of Mrs. Thomas Eakins and Miss Mary Adeline Williams, 1929.

65. *Salutat,* 1898. Oil on canvas, 50 ⅛ x 40 inches. Addison Gallery of American Art, Phillips Academy, Andover, Massachusetts. Gift of an anonymous donor.

66. *Students Wrestling,* ca. 1883. Albumen print, 4 x 5 inches. Metropolitan Museum of Art, New York City. Gift of Charles Bregler, 1961.

67. Circle of Thomas Eakins, *Two Males Wrestling,* ca. 1892. Platinum print, 2 ¾ x 3 ⅞ inches. Pennsylvania Academy of the Fine Arts, Philadelphia. Charles Bregler's Thomas Eakins Collection, purchased with the partial support of the Pew Memorial Trust.

68. *Wrestlers,* ca. 1899. Platinum print, 3 ⅝ x 6 inches. Hirshhorn Museum and Sculpture Garden, Washington, D.C.

69. *The Wrestlers,* 1899. Oil on canvas, 48 ⅜ x 60 inches. Columbus Museum of Art, Ohio. Museum purchase, Derby Fund.

71. *Male Students in a Seated Tug-of-War,* ca. 1883. Albumen print, 3 ¾ x 4 ¾ inches. Detroit Institute of Arts. Founders Society Purchase, Robert H. Tannahill Foundation Fund.

73. Circle of Thomas Eakins, *Thomas Eakins at About Age Forty,* 1880s. Albumen print, 8 ¼ x 3 inches. Thomas Eakins Research Collection, Philadelphia Museum of Art. Gift of Mrs. Elizabeth M. Howarth, 1984.